Introduction

Brecon, named after the ancient King Brychan who once ruled here, lies in the heart of one of the most beautiful and unspoilt areas of Wales. The old county took the name Brycheiniog and is also called Brecknock (for reasons that are not obvious to me).

Brecon is a bit of an enigma but enigmas appear to be the norm in this charming and ancient borough. I have pondered how to describe the town. It doesn't appear to need a reason to exist like some of its neighbours, which require accolades like 'Ancient Town on the Marches' or 'Town of Books' on the road signs as you enter their environs. Brecon is comfortable with itself and doesn't need to justify its existence; it is there and that is enough. But what makes it what it is? Its glorious location in the heart of national parkland? The castle built by the French invader to subdue unruly locals? Its cathedral standing high above the town watching over the inhabitants? Or maybe something else?

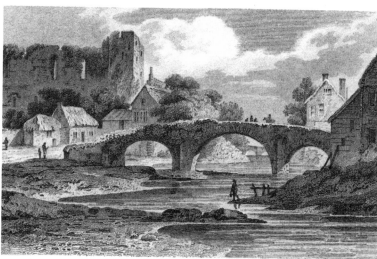

There is more to this place; the military influences are self-evident in the town and the population, much of which is made up directly or indirectly from soldiers who came here as part of their military service and stayed. Where else might you find streets with strange names that do not appear to derive from either the Welsh or English language, or streets that are named 'Inferior' and 'Superior' and more?

During our tour of Brecon we shall look at some of these enigmas. None shall be solved, but the ghosts that walk these ancient streets shall be evoked and Breconians ancient and modern visited! Stones will be overturned, but only to demonstrate the charisma that welcomes and gives shelter to all who visit or reside here. Brecon is, after all, the town of my birth and like all Breconians just a glimpse of the peaks Penyfan, Corn Ddu, Crybin and Fan-y-Big, the sentinels that watch over the town, tell me where I am: Home!

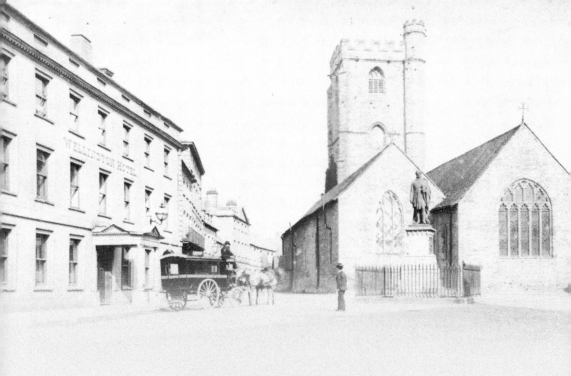

BRECON

THROUGH TIME

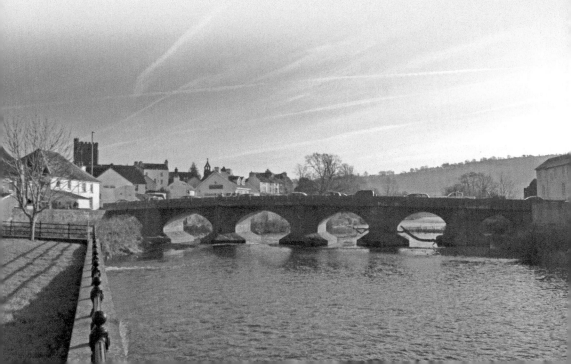

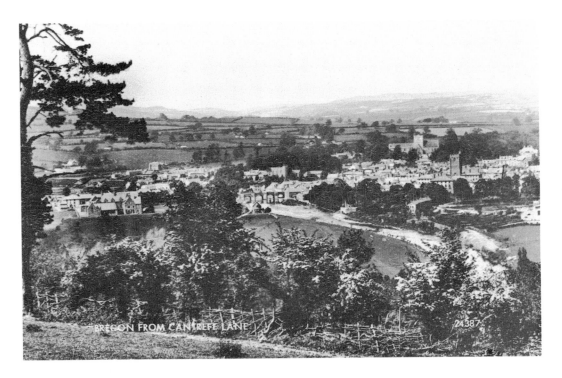

A View of Brecon Town

This old postcard view was taken from the misspelt Cantref Lane. There are no Roman connections to my knowledge, but this lane was always been known as the 'Old Roman Road' by local people. The modern picture was taken from foothills of Cribin near the ancient Gap bridle path that runs from Cantref through the Brecon Beacons to Merthyr Tydfil.

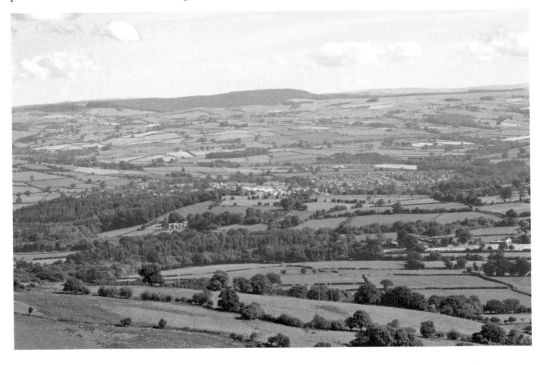

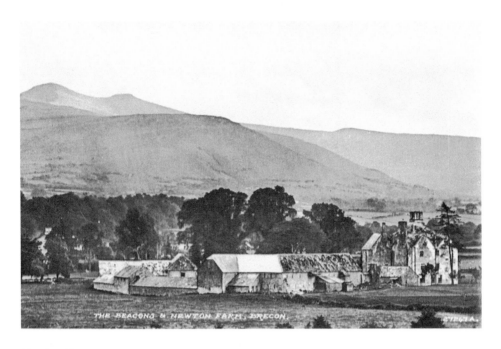

Newton Farm

Between the Tarell and Usk rivers stands the ancient Newton Farm. This charismatic building lies in the centre of the town's golf course, and the fields between this and the confluence of the two rivers were once the home of Brecon Show. The Brecknock Agricultural Society, the oldest in the UK, held the annual show here every September. It suffered desperately from bad weather, which eventually forced a change in its calendar; the event currently takes place in The Watton. In the background of the modern picture stands the Crug Hill, (pronounced 'Kreeg'), an Iron Age hill fort that offers a superb view of the surrounding area.

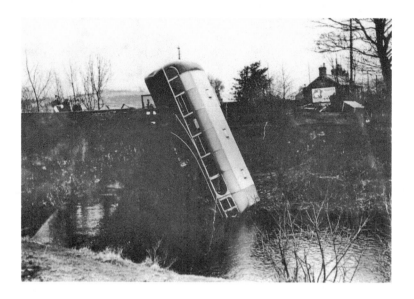

The Old County Gaol

Close to this bridge, where a coach has come to grief, stood the Brecon County Gaol. Several reminders of this grim building remain, including parts of its walls and the prison governor's house. In times past the townspeople congregated here to watch the public hangings from the banks of the Tarell and several gruesome accounts survive. The condemned were buried within the prison grounds. Were they ever reinterred or do the ghosts of those put to death still roam here?

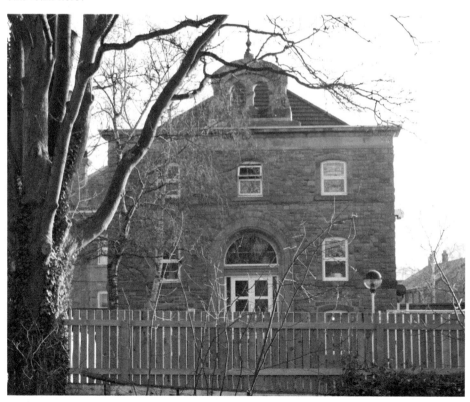

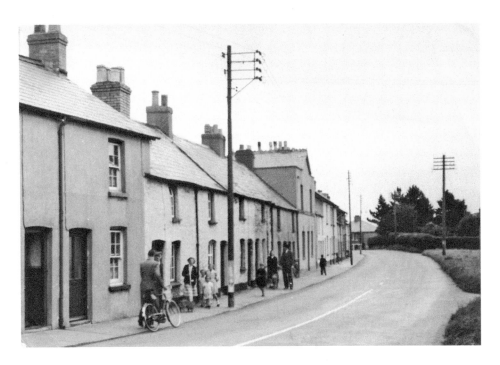

The Western Entrance to Brecon

Newgate Street, just over the Tarell Bridge, is where we enter Brecon from the west. It is probably named after the hated toll-gates that blighted the countryside during the time of the drovers. A nearby inn named the Drovers Arms commemorates this. The modern street is instantly recognisable, though some houses have been rebuilt, I am a little taller than I was in this picture, and the once pretty Gwtws path nearby has lost most of its charm due to housing development and flood precautions.

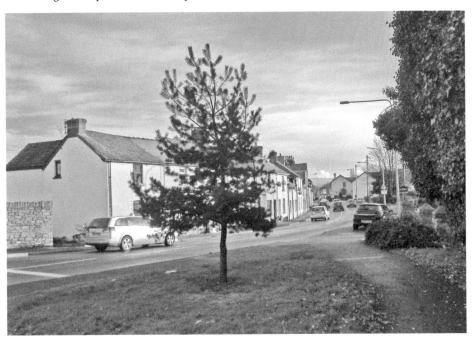

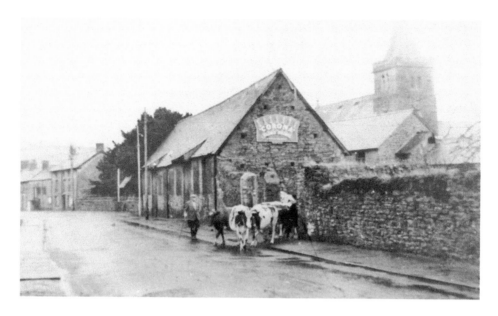

Old Castle Farm

Here we see farmer David Williams driving cows from the milking sheds back to their pasture nearby. I remember being sent here by my mother with a jug to purchase milk when I was very young. Alas no more. Nowadays the milking parlour has been replaced and tyres are sold here instead of the wonderful creamy milk. Castle Farm once occupied much of Llanfaes and was, I'm reliably told, the castle's own farm, hence the name. The farmhouse in Llanfaes is still owned by the Williams family. Across the street is Penypentre and it was here that Thomas Davies once lived. Known locally as 'Middle of the Road Tom', this colourful individual was employed at the nearby gaol and is remembered for driving a pig through the crowds on the way to church every Sunday, much to everyone's annoyance. The porker was allowed to forage in the nearby Big Field before being driven back through the crowds at the end of the service!

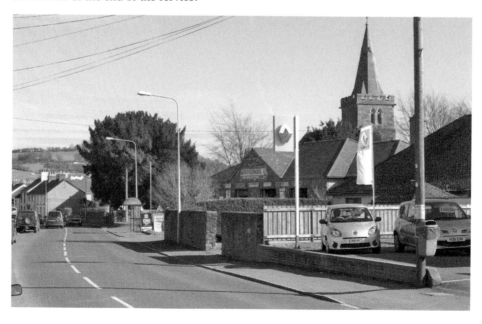

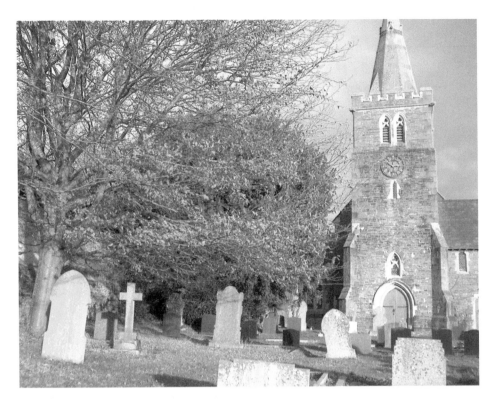

The Church in the Meadow

Llanfaes, as it is in the Welsh tongue, is dedicated to the patron saint of Wales. It sits near the Big Field in the shadow of Crwcus Hill, and here we see a group of volunteers who were tasked with keeping the churchyard grass under control – no power tools in those days.

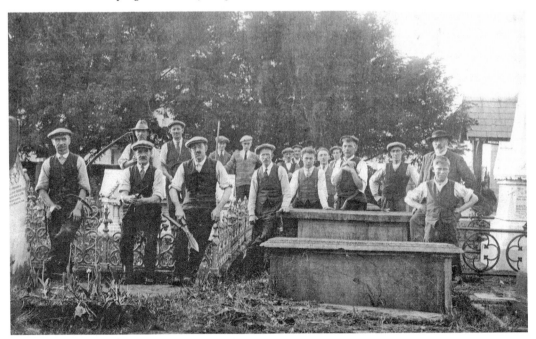

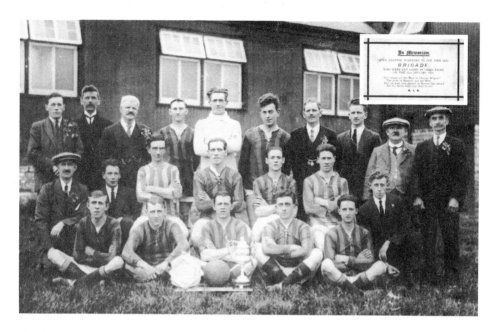

Llanfaes Parish Hall

Footballers from Llanfaes Scouts FC at the parish hall in 1924. Back row: W. B. Hargest, J. Bowen, J. J. Walters, W. B. Bufton, E. F. Bowen, J. Bowen, W. Hargest, H. G. Richards, T. J. Perry, T. H. Richards. Middle: W. Francis, J. H. Mullen, T. J. Richards, S. J. Cootes, E. J. Pritchard, T. A. Davies, W. R. Havard. Front: A. Ll. Rees, A. E. Webb, W. A. Webb, F. W. Richards, A. G. Evans. Note the banter following one match involving Llanfaes Church Lads Brigade (inset). The parish hall was home to many social and sporting organisations; the WI (Women's Institute), Mothers' Union and GFS (Girls' Friendly Society) were extremely popular and dances and whist drives were regularly held here. The Big Field or more correctly Alderman Thomas Williams Playing Field (as no-one calls it) remains a popular haunt for local children to play.

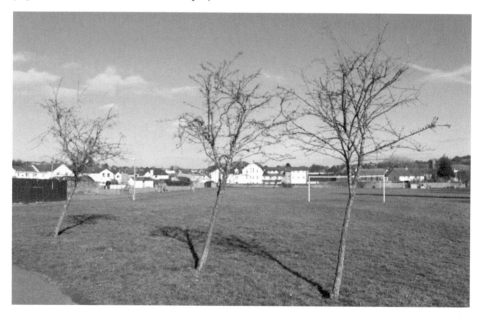

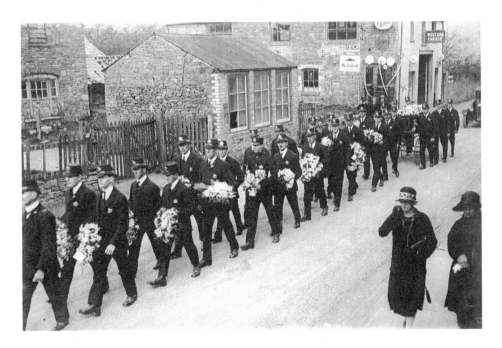

The Golden Wall

A funeral procession passes Westend Garage, which is a little difficult to recognise. It was common practice until the 1960s for a service to be held in the deceased's home but the actual funeral tended to be a men-only affair. What is the uniform being worn here? Railway, mail, militia? The stone wall adjoining the modern garage is nicknamed the 'Golden Wall', so called because locals felt that its construction (by the local authority in the 1960s) took rather longer than it should have, at great cost. In the cottage behind the Golden Wall a shoemaker plied his trade.

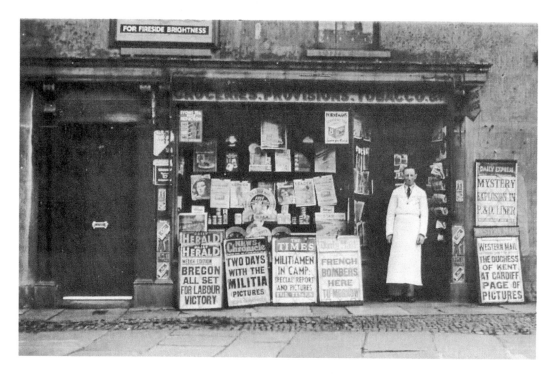

Orchard Street and the Almshouses

On the cobbled area just before the eastern entrance to the Big Field recreation area stood a newsagent's shop seen here in 1929. I believe the shopkeeper at the time was a Mr D. H. Evans and that the Labour Party was indeed victorious in the election advertised here. In the colour photograph we look towards Church Street and the almshouses and the junction of Newmarch Street.

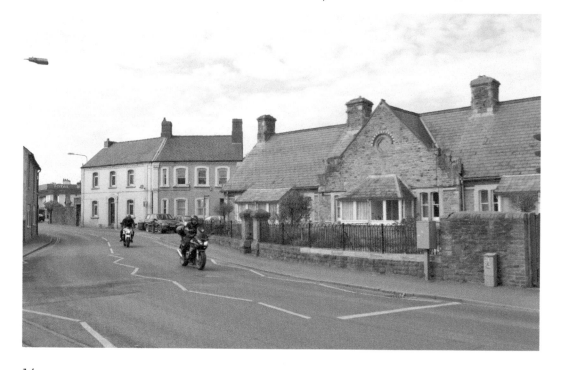

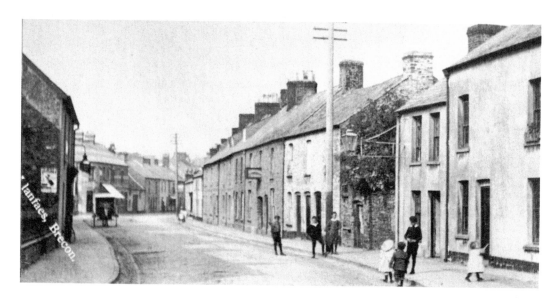

Shopping in Llanfaes

It is difficult to picture the large number of shops that once did business in this part of Llanfaes. Opposite the newsagent was an electrical/fancy goods shop run by the Bowley family and a few doors away, opposite the Three Horseshoes Inn, was the tiny sweet shop of Horace Jones and his wife. Near the almshouses was Talbot Stores and next to the primary school was the Corner Shop selling wonderful cakes among other things. Just a few yards distant stood the Llanfaes post office, so that every building in this short street, even the tiny no. 40 Church Street, was once a shop.

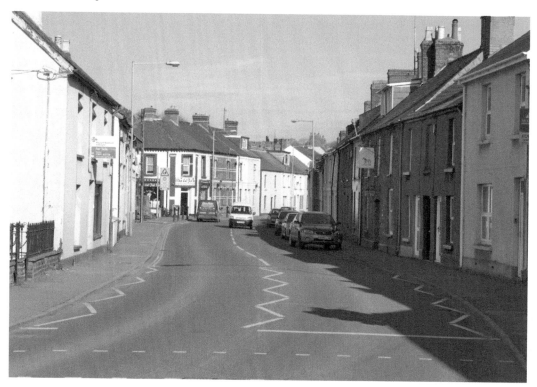

Llanfaes Junior School

This school was once located on the junction of St David's Street and was ruled by headmaster E. B. Powell during the 1950s and '60s. This fearsome gentleman wore a brown leather cover over the stump of his severed hand and was not averse to cuffing delinquent scholars with it if he thought he or she deserved it. I well remember getting caned for failing a maths test, with the threat of worse if I didn't improve! Here we see staff and pupils from the class of 1899 that had not missed attending school for a whole term. The current school is located on the Bailyhelig Road, in the shadow of the town's old workhouse.

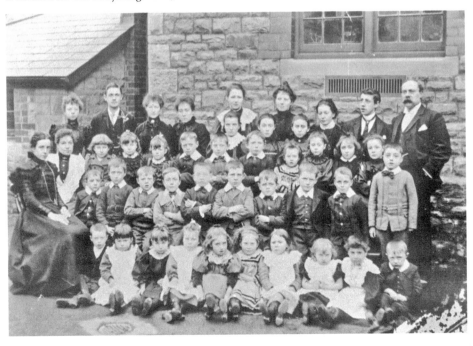

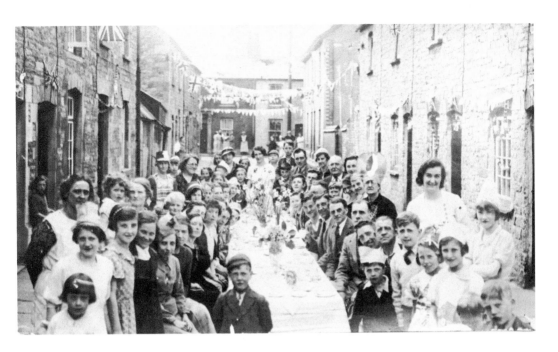

Party Time in St David's Street

I'm not completely sure what great event is being celebrated here, but it is quite possibly a coronation or a victory party. I wonder if scenes like this will ever be repeated with such verve. This street is instantly recognisable as is its neighbour, Newmarch Street. These, unlike some of their neighbouring streets, have maintained their residential status. The old corner shop is now a fish and chip shop.

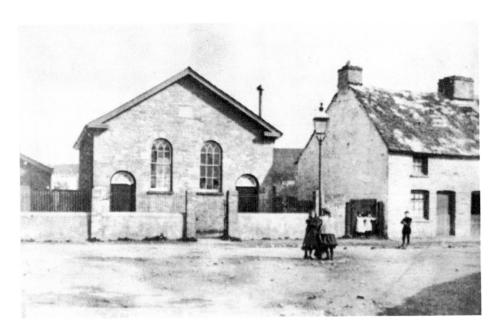

Westend Youth Centre

The old chapel at the foot of Newmarch Street nowadays seems to be occupied by the Westenders theatrical group. It lay dormant for several years following its closure as a place of worship until protestations by local boy Winston Griffiths to the sitting Member of Parliament about the lack of amenities for the young people of Llanfaes led to its resuscitation. For several years it was a youth club and the music of the era was performed every Saturday night by local groups The Amazons (surprisingly all male), and The Presidents. Rock and roll ruled. Winston went on to become a Member of Parliament, restyling himself Win Griffiths. One of his foremost achievements was setting up the Welsh Ambulance Services NHS Trust.

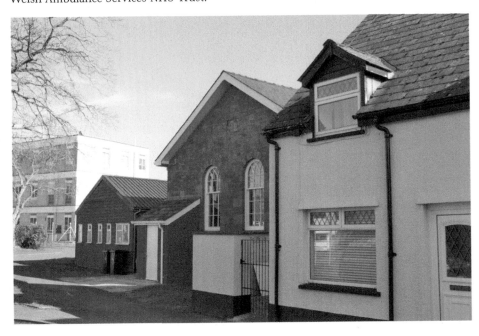

Death of a Community

Heol Hwnt (Road Beyond/Yonder), or Silver Street as it later became known, was once a busy residential street as can be seen here. The whole area has suffered from unsympathetic development. Other than the few exceptions seen here, the whole street, together with nearby Cwrtymor and Spring Gardens, has completely disappeared to be replaced by a plethora of unspecific, ugly commercial buildings.

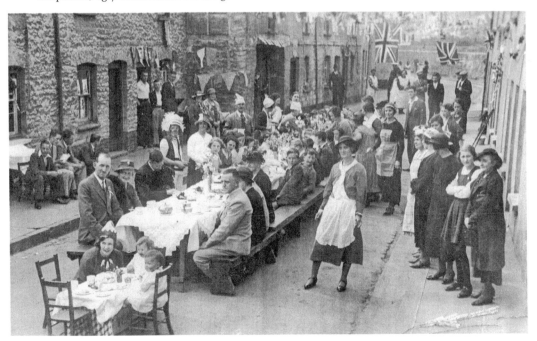

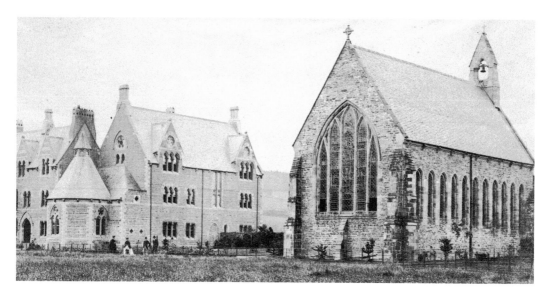

Henry VIII's Legacy

Contrary to my expectations, this ancient seat of learning is surprisingly short of reliable ghosts; however a certain Bishop Lucy seems to have connections with several anecdotes that concern pranks rather than actual sightings. The foundations of School House (with the octagonal building based upon a French kitchen) were laid in 1853. Although the buildings have changed little over the years, there has been a considerable change in their use. Computers sit where the master once supervised prep from a dais in the big school room and members of staff now take their morning coffee in a room that has been a laboratory, a dormitory and a careers room. Even so a time traveller would still recognise the buildings, whether prefects and colours or prep and tuck. Reading through *The Breconian* (the school's magazine) you find the same sense of humour and the same sense of purpose and spirit. I find that continuity fascinating.

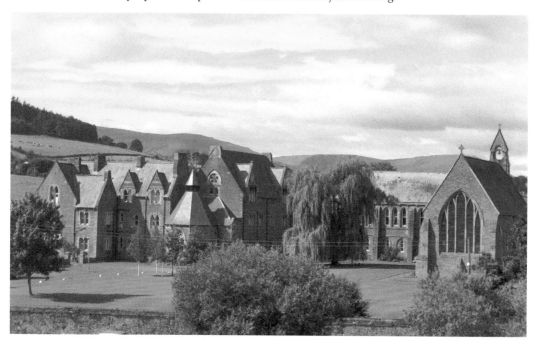

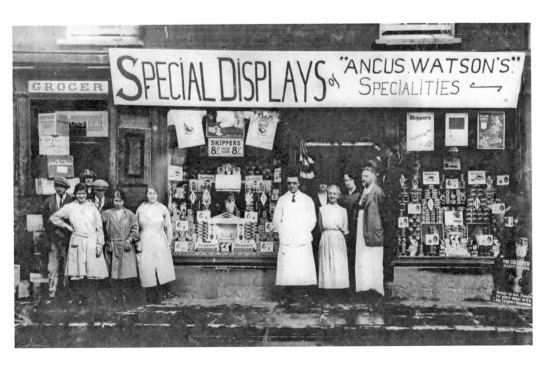

The Changing Face of Llanfaes

Victor Morris' grocer's shop in Bridge Street was possibly the largest of the many shops that once graced the Llanfaes streets. Here we see Mr Victor Morris, the bearded gentleman, with some of his staff. Obviously 'Skippers' branded goods were being heavily promoted that week: 'Ready to eat foods for every meal' the poster tells us. The brand has since disappeared. Nearby Llanfaes Dairy is one of the survivors, unlike the Cross Keys Inn and the Flag and Castle, which are long gone.

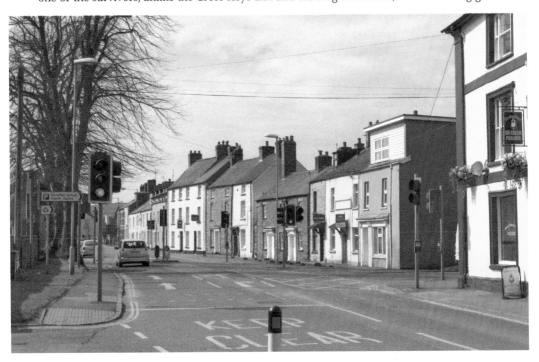

Bridge Street Back in the Day

Besides Victor Morris' there were several other businesses here back in the day; we had Sullivan's hardware shop and Hilda Davies' tobacconist's and confectionery shop near the bridge. In between was the popular transport café The Greyhound, located near the three stone steps seen midway along the terrace. At night the street was filled with lorries parked overnight opposite The Greyhound, taking a break on their journeys all over the countryside.

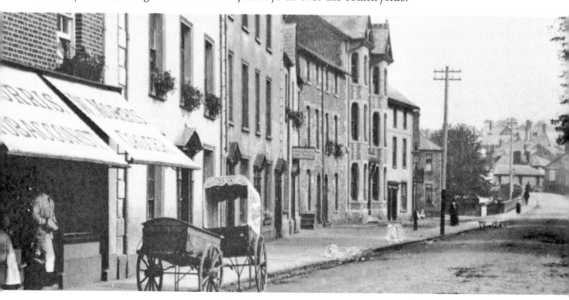

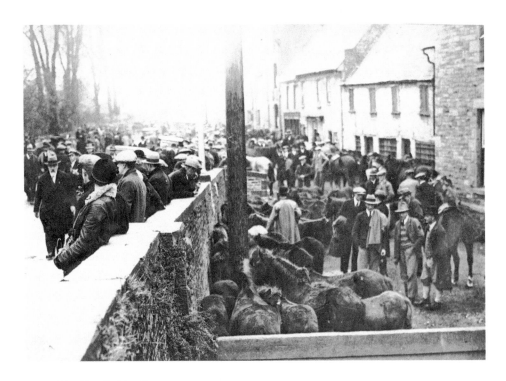

Horse Trading in Llanfaes

Every small town and village seemed to have its horse fair and Brecon was no exception. This slightly over-exposed photograph of a horse sale in the 1930s shows how popular these events were. The small hardware shop and confectioner mentioned earlier can be seen here. Note the plank barrier in the foreground that was a feeble attempt to keep the waters of the River Usk in check. Little wonder that Brecon, and Llanfaes in particular, suffered so often from flooding.

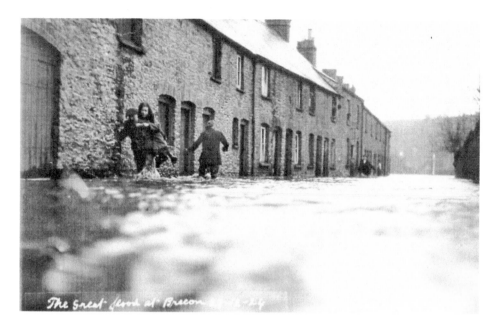

The Great flood at Brecon

The Tempest

All too often the Usk overwhelmed the flimsy flood defences that we saw in the last picture and the poor people of Llanfaes were subjected to the wrath of the swollen river. Bridge Street suffered regularly and the filthy waters sometimes reached well into Orchard Street. Brecon's flood defences have been improved over the years and scenes like these have thankfully become a rarity. The worst flooding in living memory happened in around 1973 when the Tarell broke its banks at Gwtws and the waters rushed down Silver Street meeting those of the Usk near the college entrance. Ted Brown, a resident of Orchard Street, was inside his garage at the time. He told me that one moment he was busily working, the next he was up to his chest in water.

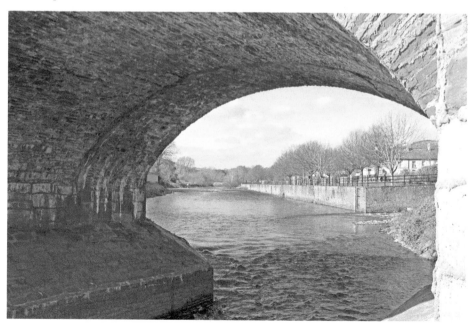

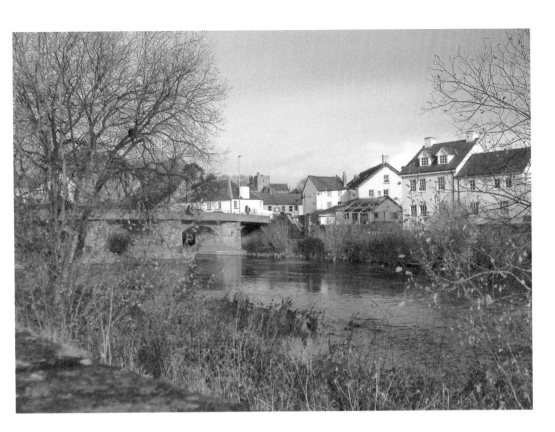

Dinas Road

The worst of the fury of the river was reserved for the poor residents of Dinas Row, seen here. These pretty cottages flooded with alarming regularity and eventually all of these dwellings, with the exception of the old Bridgend Inn, became uninhabitable and had to be demolished. This lane originally led to the imposing Dinas House, about 2 miles distant, passing the tennis club a short distance along the way. Dinas House is no more and Christ College has absorbed the old tennis club into its environs.

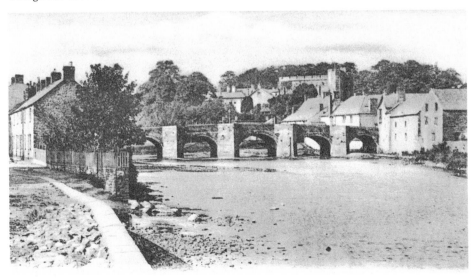

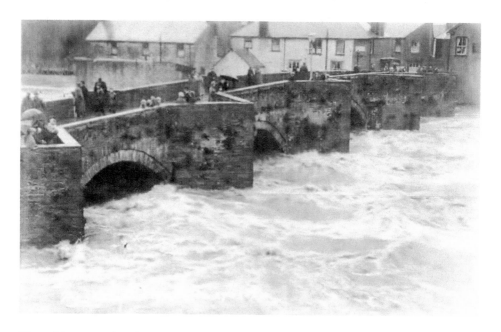

The Bridge Over the River Usk

The present Elizabethan bridge over the Usk replaced the medieval bridge destroyed in the floods of 1535. Extensively repaired in 1772 and widened in 1794, it remained a pretty construction as seen here during one of the river's seasonal high waters in 1924. Salmon and sea trout (known locally as 'sewin') travel upstream during the November rains to spawn in the small streams where they were born, closely monitored by interested locals. The bridge was never intended to carry modern traffic and consequently had to be widened during the late 1950s. Unlike Builth, where the whole edifice was widened, maintaining its charm, Brecon took another, less appealing route. The current bridge is functional and safe but extremely ugly!

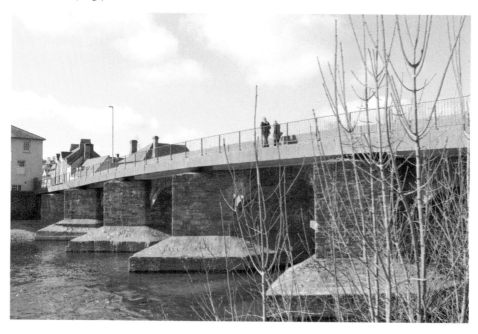

Royal Visit

Crowds turn out to welcome the heir to the throne to Brecon in July 1969. He came to open the town's new library which had replaced most of the northern side of Ship Street. Even the drinkers in the nearby Boar's Head Inn came to the door and raised their glasses as he passed. It is said that he responded with a look that suggested he would have preferred to have been in their company in the bar rather than opening public buildings that day. The interestingly shaped building seen here was a popular newsagent's and fishing tackle shop at the time, W. F. Hutchinson's, or 'Hutchies' as it was known.

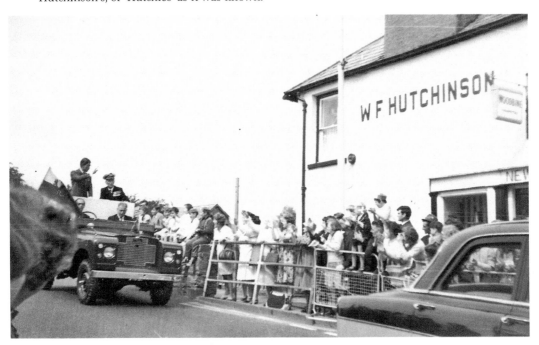

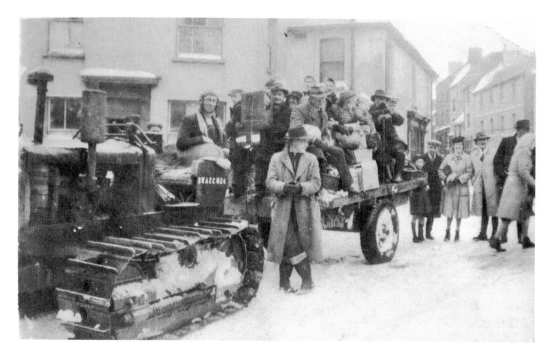

Beating the Winter Weather

This snow scene is difficult to date but is probably from the extreme winter of 1947. Much redevelopment has taken place here over the years. All the buildings behind the tractor have since disappeared during Brecon's renaissance. The building immediately behind the tractor was a very popular café during the 1960s. Many a 'frothy coffee' was served by Bert Arkinstall while the jukebox played the music of the day – The Beatles, the Rolling Stones, Elvis Presley and Roy Orbison. Bert's Café was the place to be then!

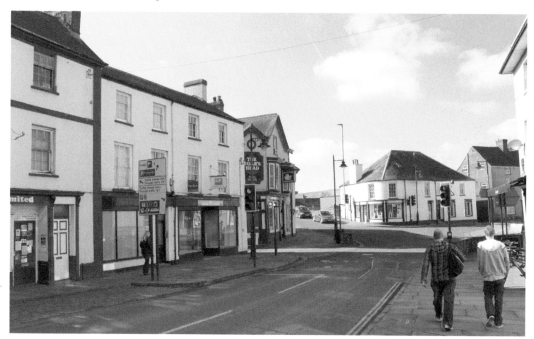

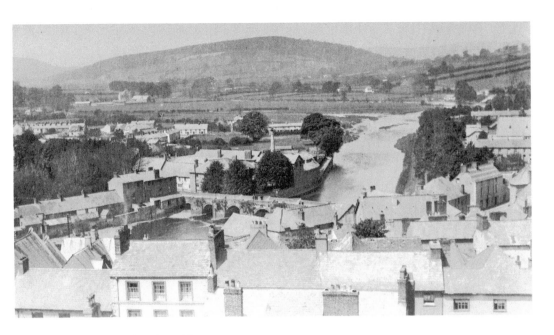

Aerial Views of the Riverside
This lovely view looking towards Llanfaes Bridge was probably taken from the top of the tower of St Mary's church. Also seen here are Dinas Row, the Bridgend Inn, Silver Street and Cwrtymor long before unfortunate planning decimated the area. One can also see the original Newton Green looking over the golf course to Newton Farm.

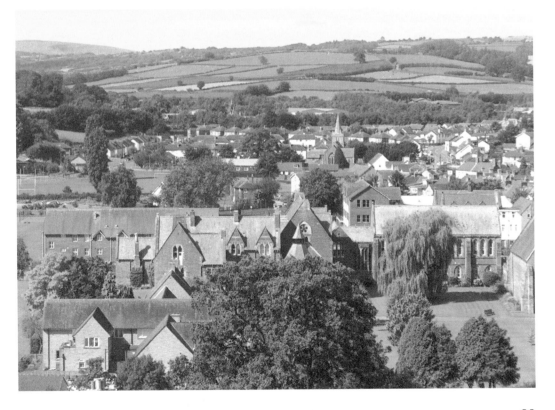

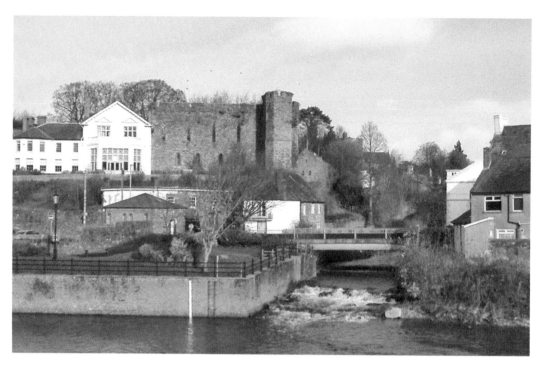

The Three Bridges of Old

This wonderful picture not only clearly shows the three bridges over the Honddu, but the Watergate chapel and watermill (long before the word Watergate became infamous). In the background we see the remains of Brecon's castle and in the distance the cathedral. Of the three bridges, one has been replaced, one removed completely and the other closed to traffic.

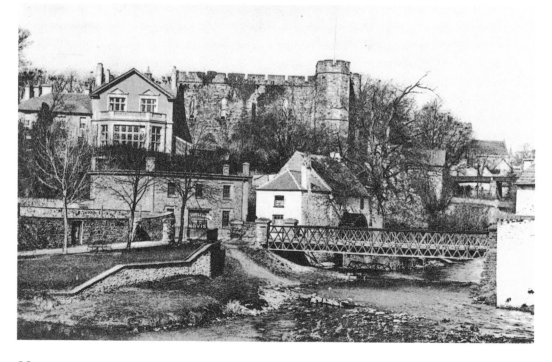

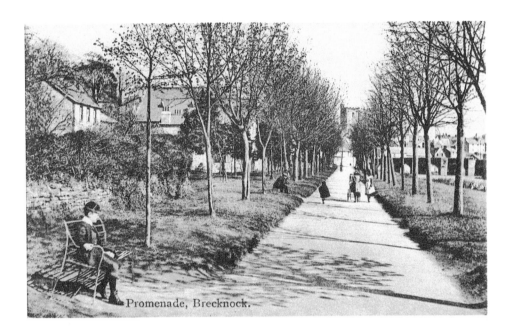

Promenade, Brecknock.

Promenading Brecon-Style

The Promenade remains a popular walk for visitors and local people, although the trees have developed somewhat since this photograph was taken. The only major change is the addition of the flood walls that enclose the Usk to contain its fury during high water. The walls on the riverside are both necessary and to a degree not unpleasant. However the flood walls near the path close to the canal intake are unbelievably ugly. I suggest that the Town Council requests assistance from our friends in the military in the art of camouflage and concealment. I'm sure that discreet planting of shrubs could hide these ugly walls without harming the flood defences, and may even enhance what is after all one of Brecon's finest assets. It seems that in this area Brecon has become a walled town again!

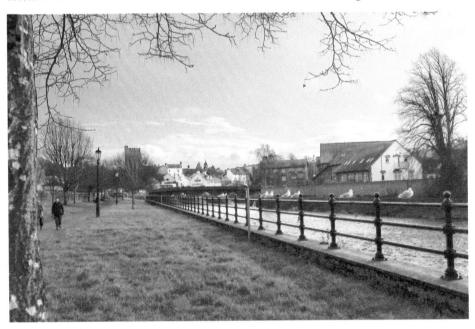

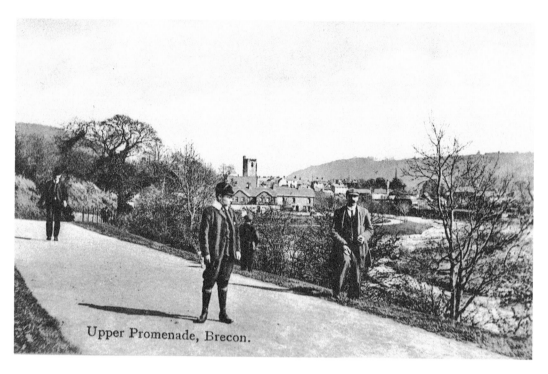

Upper Promenade, Brecon.

The Upper Promenade

An interesting view looking towards the town and St Mary's church tower. The young man in this photograph is the same person we saw earlier sitting upon a bench. The uniform may be that of Christ College and perhaps he is related to the photographer.

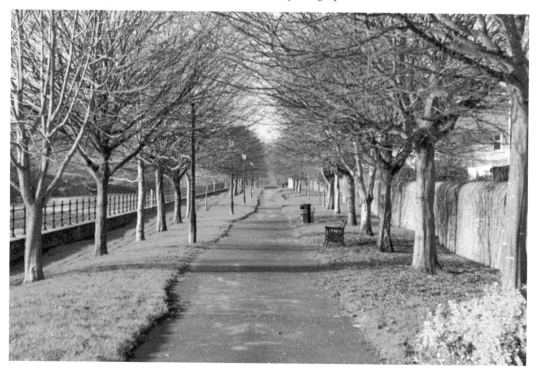

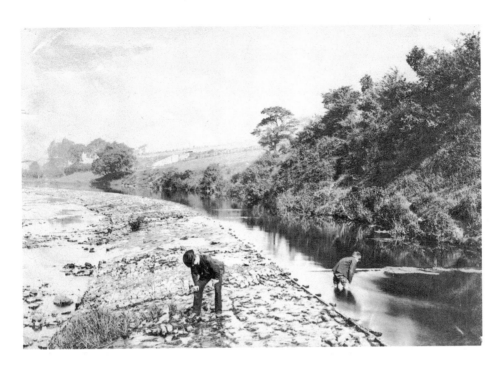

The Weir and the Canal

I am told that these gentlemen are fishing for eels along the weir that diverted the river water towards the mill near today's canal intake. This construction of the canal provided deeper water to allow the swimming and boating that made Brecon an extremely popular destination during the long, hot summers of the 1960s. Families from the industrial Merthyr and Gwent Valleys flocked here in their thousands to relax and take a boat on the river at weekends.

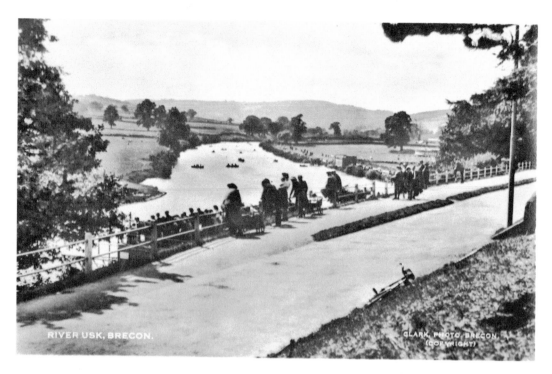

RIVER USK, BRECON. CLARK, PHOTO, BRECON.
(COPYRIGHT)

Postcard from the Promenade

This postcard taken by local photographers Clark of Brecon shows how popular boating and promenading was. Note the large audience watching the bathing and the landing stage on the Newton side of the river. Near this part of the promenade once stood a bandstand where the crowds were entertained. Sadly the promenade swimming club is no more!

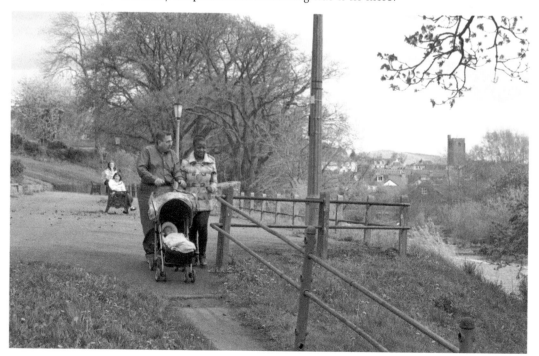

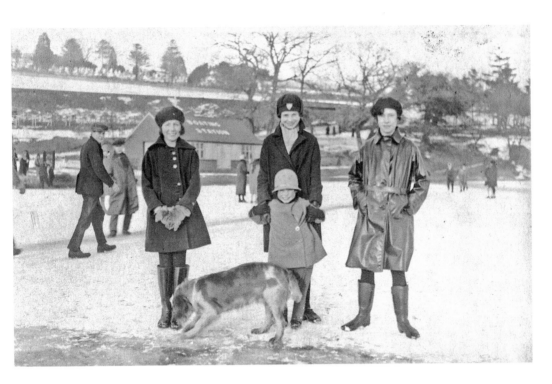

The Big Freeze of 1963

Walking on the frozen River Usk. Here we see members of the Clark family posing on the ice in the big freeze of 1963. One could walk safely right across the river and for a considerable distance upstream. One local man cut a hole in the ice using an axe to see exactly its depth. It is rumoured to have been 3 feet deep. The Boathouse did great business with hot drinks but the ferry and boats were not required!

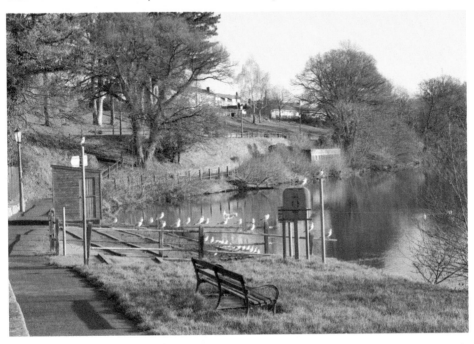

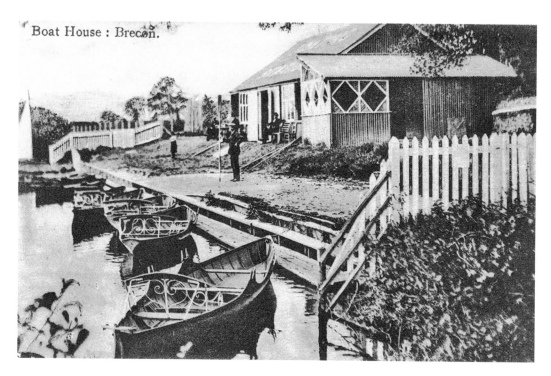

Boat House : Brecon.

Jolly Boating Weather

Here we see some of the rowing boats that were for hire. The whole complex was rebuilt soon after the big freeze of 1963, with better café facilities, slot machines, jukebox and boat storage. The popularity of the Boathouse was extremely high during this decade and although it may have diminished a little it is still a major attraction during the summer months.

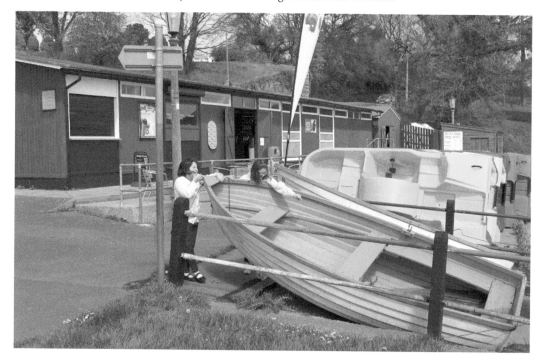

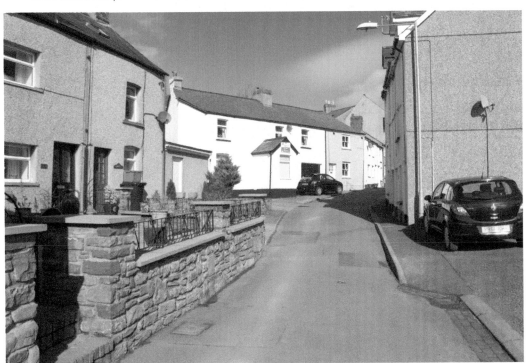

Brecon's Little Gems
Brecon's Mill Street originally led to this water-powered mill, not too far from the present-day canal intake. Mill Street is one of Brecon's little gems, along with Kensington, Dainter Street and the other narrow streets nearby. Old and with character, its small dwellings provide not just homes but a little community.

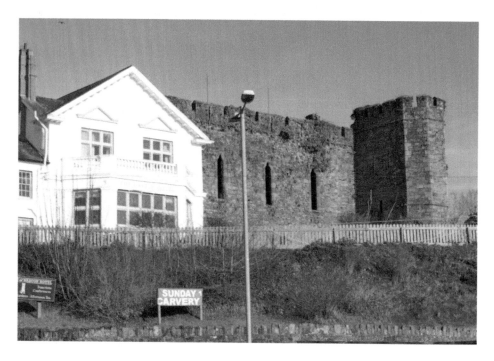

The Castle Keep

The town's Norman castle was originally built to subdue the unruly local tribes and Brecon, unlike its neighbours, was a walled town. Fragments of the town's walls remain and are relatively easy to find, but, in my opinion, the most interesting part of the castle is hidden from all but the most inquisitive viewer. On the hill behind the hotel in the grounds of the Bishop's Palace stands a fragment of the keep. Just to the left of this, if one peers carefully through the trees and dense undergrowth, one can spy a cannon pointing down Castle Street; a veiled threat high above the town.

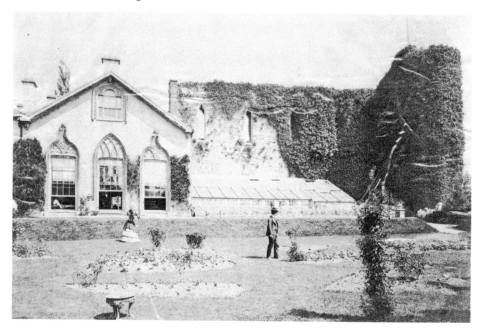

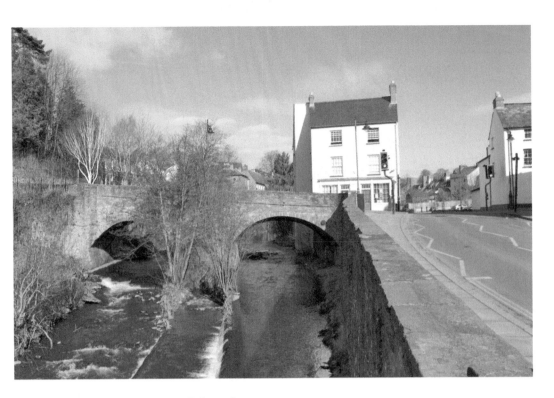

Castle Street Before the Relief Road

One of the businesses in Castle Street near its junction with Market Street. Next door to this was the Black Lion Inn, very popular with underage drinkers (myself among them) in times past, especially on market days. A new relief road has forever changed the character of this area, taking the Black Lion into history.

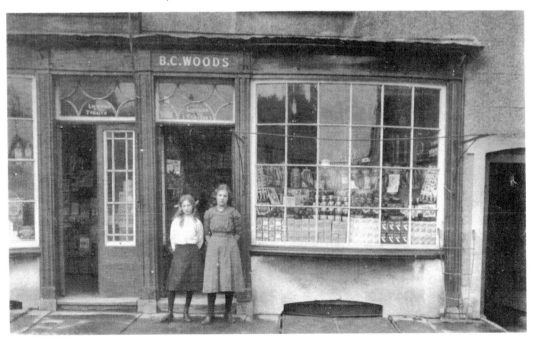

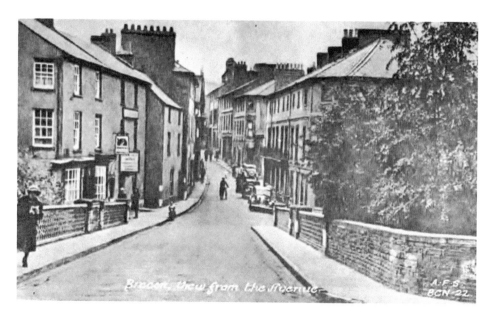

Brecon's Original Main Street

Almost every building in Castle Street was once a shop, café or trader of some kind. Here also the Market Hall draws people into its precincts. Tearooms, bakers, confectioners, tobacconists, alehouses and all manner of businesses plied their trade here. This bridge has gone and traffic no longer passes over its replacement into what once was the most important street in town, the street leading to the castle.

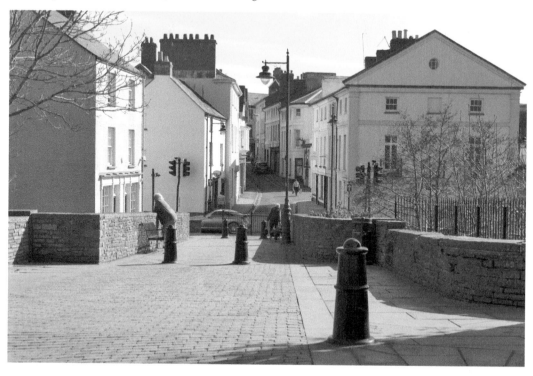

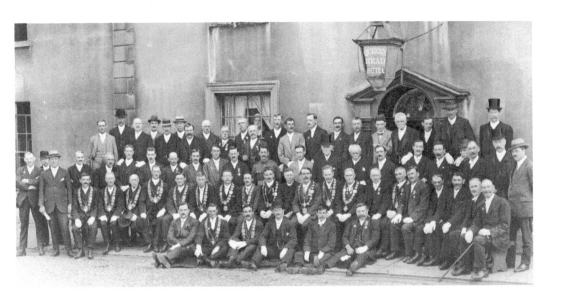

The Queen Loses her Head!

In a small square near the junction of Market Street with Castle Street stood the Queen's Head Hotel. The identity of this meeting is not clear; could it be the Royal Order of Water Buffaloes? I find it interesting that nearly every man present, even the one peering through the window, is sporting a moustache. Fashions and fortunes change and the Queen's Head has vanished without trace.

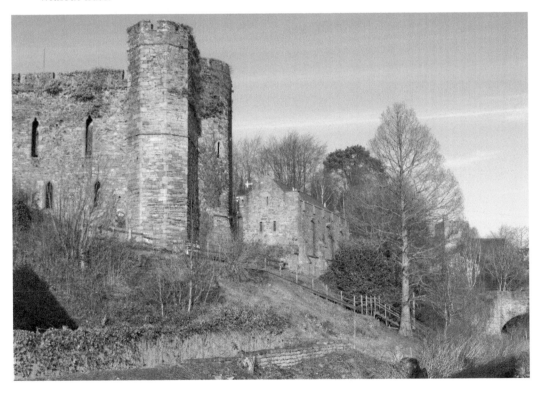

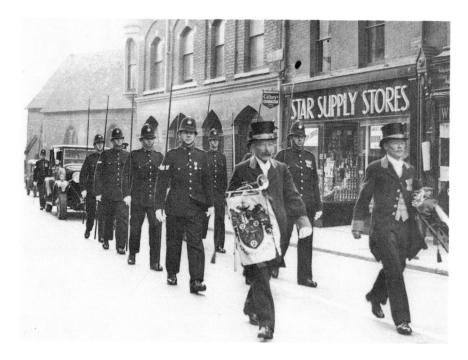

The Postern Gaol

The assize courts were originally held in a courtroom in the town gaol in the Postern. This establishment was where debtors were held – by all accounts not in the lap of luxury. At the time, the circuit Judge crossed the river from his lodgings in the Struet, unseen and in safety, to dispense justice from here. However, Mr Harry Symonds, who resides at the Postern Gaol, tells me that when the new assize court was built on the Watton Mount the Judge was several times attacked as he made his way to and from court, hence the procession and armed police escort for the visiting Judge in 1935.

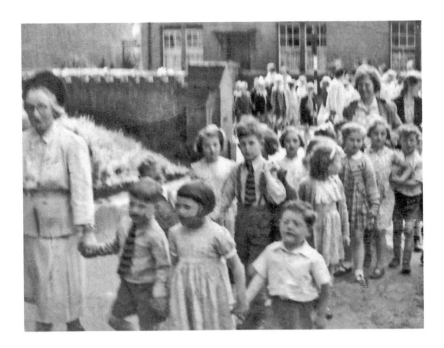

Church Parade

Children from Brecon primary schools are seen here attending the Ascension Day service at Brecon Cathedral in around 1953. Religious events such as this no longer seem to feature in the school curriculum for some reason; the children, I can assure you, thoroughly enjoyed an afternoon off school to attend. The cathedral, formerly the priory church of St John the Evangelist, is viewed from the lych gates in the modern picture. These ornamental gates were fabricated by a local blacksmith, Thomas Davies of Church Street, while employed by local company Coppage & Sons.

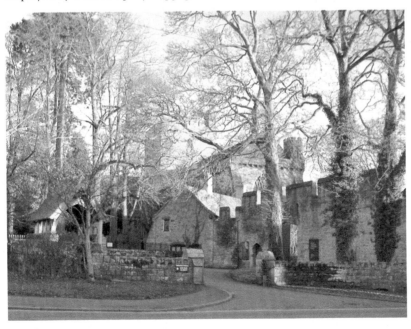

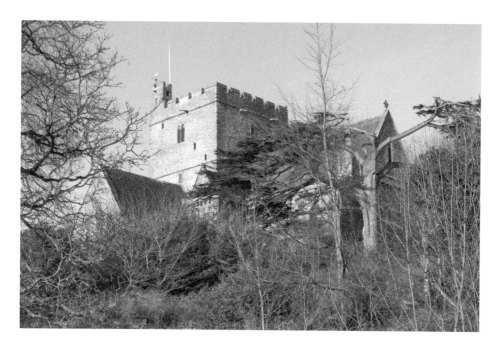

Brecon Cathedral

The enthronement of Bishop E. W. Williamson in 1956. The solemn procession is led by Cathedral Verger Albert Tilley followed by John de Winton, Registrar. The Bishop is supported by Chaplains Revd G. I. R. Jones and Revd N. L. James. Albert Tilley was a renowned local historian and among other things was responsible for carrying out the research that eventually proved that Brecknock Agricultural Society is in fact the oldest organisation of its kind in the UK.

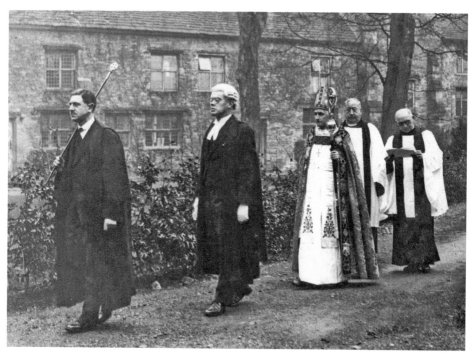

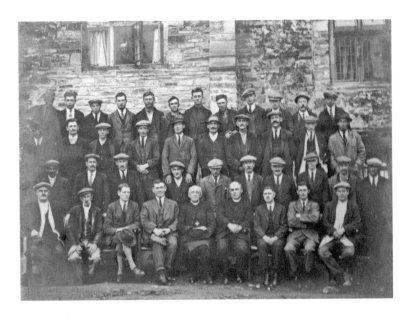

Restoration 1926/27

Many well-known faces are present among the workmen who carried out major restoration work on the cathedral in 1926/7. The work was undertaken by Williams Bros Builders, of Market Street. The names are: Window: Canon Stuart of Sketty. Back row: Tom Pritchard, Trevor Price, Ted Davies, Cyril Pearce, Doug Coombes, Randal Jones, Billy Havard, Jack Davies (Gwtws), Charlie Pearce, Ivor Howells, Sam Evans (Flag), Iorworth Davies. Third Row: Evan Cooke, Tom Price, Fred Letton, Tim Williams, Dai Price, Dai Price (senior), Jack Evans (Crofty), Jack Innes, Edwyn Hill, Fred Williams. Second Row: Harry Evans, Bill Hargest, Jack Pritchard, Edgar Parry, Dan Williams, Bill Lewis, Jack Edwards, Bill Howells, Jack Davies, Sam Cooke. Front Row: Bill Williams (Wms Bros), Jack Gittins, Harold Elston, Charlie Williams (Wms Bros), Bishop Edward Latham Bevan, Revd E. A. T. Roberts, Albert Tilley, Harry Neal (worked for Elston), Phil Williams (Wms Bros).

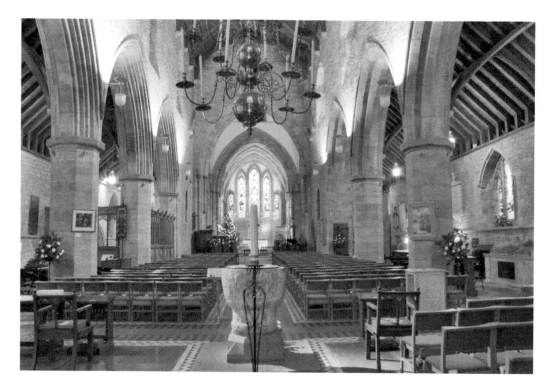

The Christmas Crib and Easter Garden

The magnificent Christmas crib and Easter garden that filled the entire south part of the cathedral nave were a labour of love by the verger. People came for miles to wonder at them and their fame was spread throughout Wales and beyond through the newspapers and media. This photograph hardly does justice to the efforts of Mr Tilley. The tradition continues but the scale is much reduced. The verger was badly wounded in the Battle of the Somme; maybe the horrid experiences of war led to his lifelong love for and dedication to Brecon Cathedral.

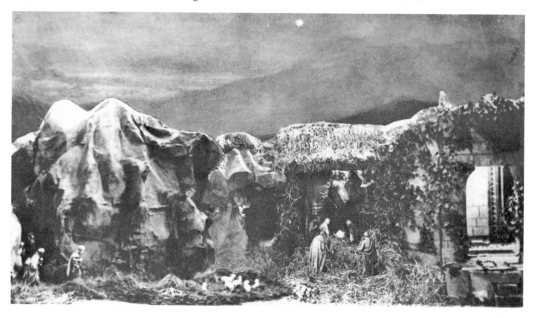

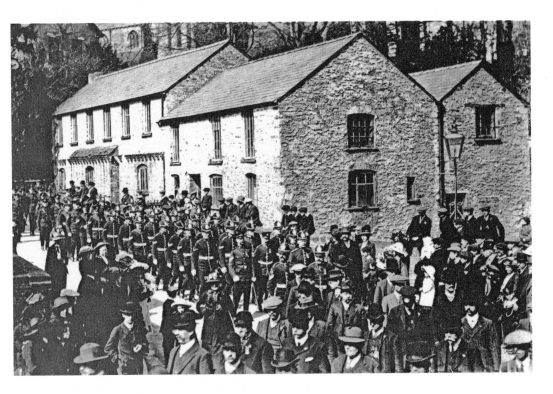

The Priory Woollen Mills

Here we see a procession marching down Priory Hill from the cathedral in around 1920. The Struet area of Brecon was very industrial at this time and the buildings seen here were part of the flannel making trade that flourished along the banks of the Honddu river.

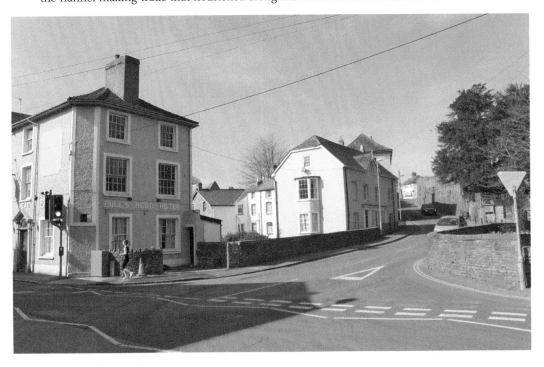

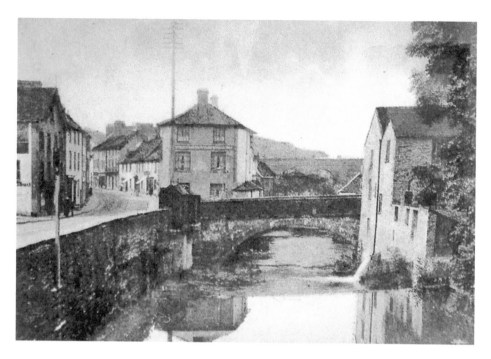

Views From the Struet

Another view of the Honddu Bridge, the flannel mill and the road leading towards the town centre. The flannel mill that flourished here for many years has gone and this area is now recreational, but it is interesting to note that those buildings still standing, with the exception of the railway viaduct, remain virtually unchanged. Not just a pleasant walk, but an interesting area of the town.

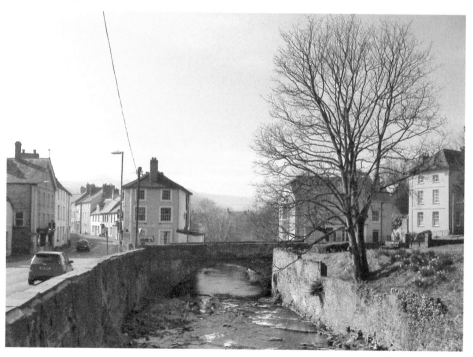

Time Travellers Coming to Brecon

Looking westward from the Honddu Bridge this old postcard shows the footbridge leading to the Priory Groves, always a popular walk, and the system of weirs that diverted the power of the river to drive the mills. The weir is long gone and the Struet is now almost entirely residential. Time travellers seem to have visited this part of Brecon recently. This sign marking the site of the expected visitation is located opposite the footbridge to the Groves.

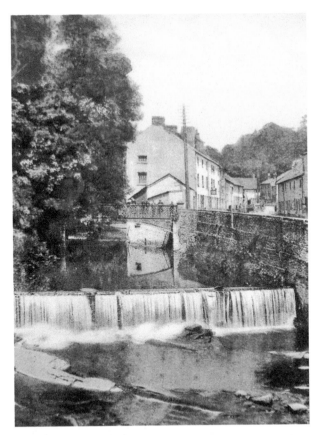

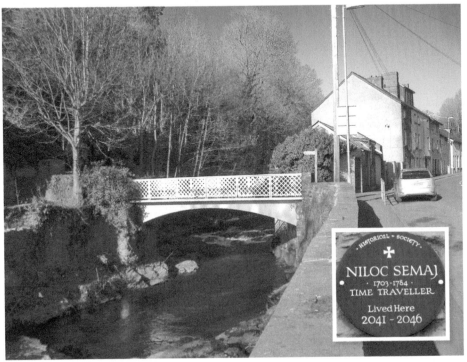

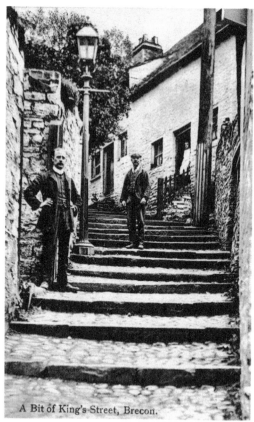

A Bit of King's Street, Brecon.

King Charles and Those Steps!

I have pondered for some time the strange names allotted to some of the streets of Brecon; what indeed is meant by 'the Struet', I wonder? The Bulwark can be explained from its location within the walled town, and the oddly named High Streets Superior and Inferior are quaint, but King Street, or King Charles' Steps as it is also known, is another anomaly. We know that Charles I spent at least one night in Brecon in 1645 during the Civil War and this quaint but intriguing lane has since been associated with him, but why?

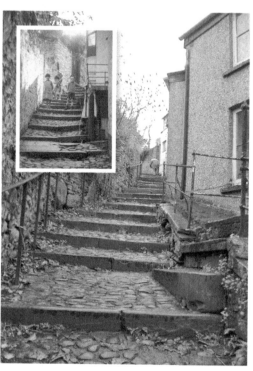

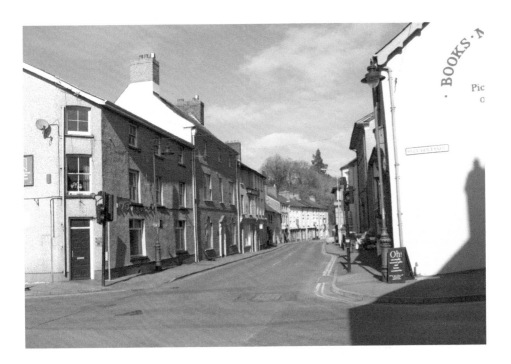

The Angel in the Struet

Looking down the Struet from the Angel Hotel in 1900. The street is quite recognisable today as its buildings have changed little. Next to the hotel was the colossal railway viaduct, since demolished, and the pink house is the building where the visiting assize court Judge lodged during his stay here. Next to the Judges' lodgings some readers may remember a printing works run by a Mr Pennar Jones, where the very distinctive red and blue cinema posters were produced among other things. Opposite, the building once known as 'The Elms', with the ornate doorway, once housed the Intermediate School for Girls (1896–1901) and later the Inland Revenue Offices.

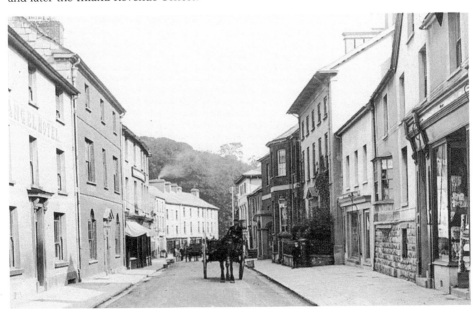

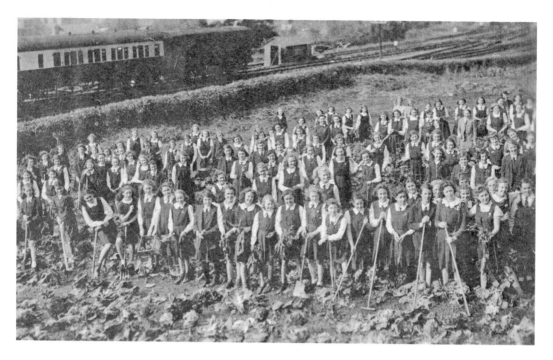

Digging for Victory!

These pupils from the Girls Grammar School in Cerrig Cochan Road are planting crops to aid the war effort, in around 1942. The piece of land being cultivated is in the Camden Road area. The colour picture looks towards the town from the approximate location of the old picture. The imposing hill behind the railway station is known as Slwch Tump. It was here that St Elwedd, a daughter of Brychan Brycheiniog, was martyred. It is interesting to note that the current Prime Minister (David Cameron) named one of his children Endellion, which was the name of another of the daughters of King Brychan.

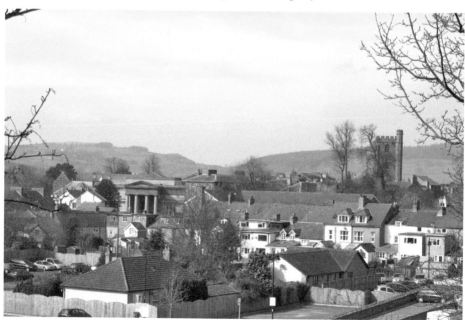

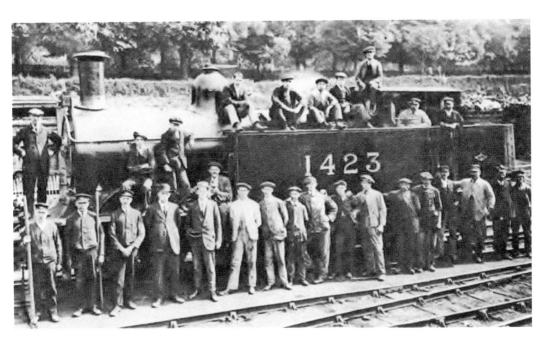

Little Free Street

Another of Brecon's quaint little streets, linking the Watton with Free Street. The former led to lower goods yard, the latter to the railway station. Here we see some of the railwaymen posing for the camera. No ''elf 'n' safety' to worry about in those days it seems!

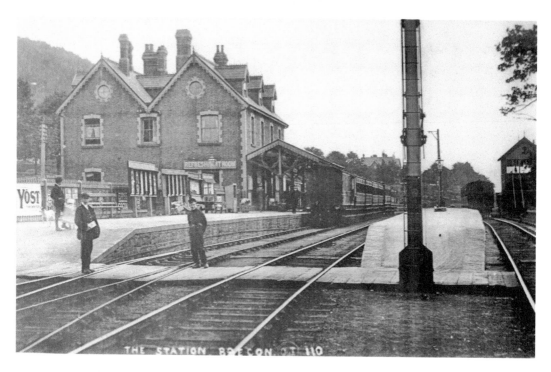

Brecon Railway Station

The once busy Brecon Railway Station in Camden Road. Several railways passed through Brecon and many older Breconians will fondly remember the Sunday School outings that left by train to such exotic places as Barry Island, Porthcawl and Aberavon. Trains were crammed full of excited children and their suffering parents, sometimes noisy, often raucous, but great fun. The line closed in 1964 and the Fire Brigade currently occupies the station site.

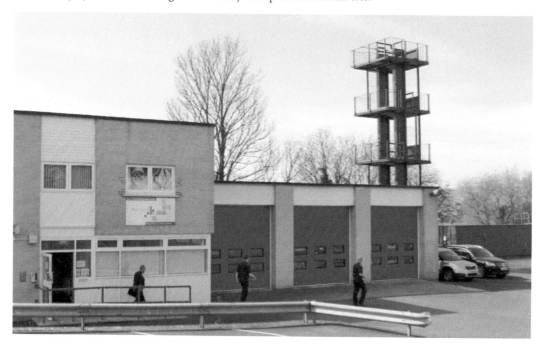

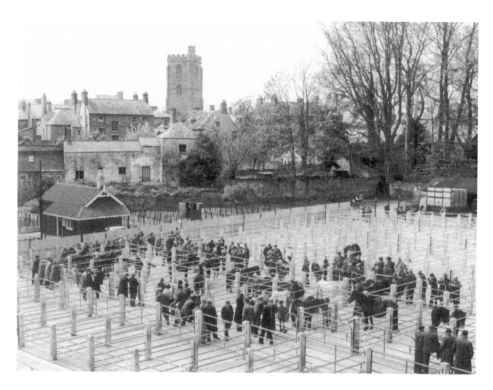

The Old Cattle Market in the Heart of the Town

Before the market was built animals were sold openly on the streets of Brecon. Market days were always busy with farmers selling their animals in the marketplace and their wives doing good business selling 'farm butter', cheese, jam, bacon and other wares in the Market Hall. The cattle market has moved out of town but farmers' markets have been successfully revived. In the background we can see fragments of the old town walls.

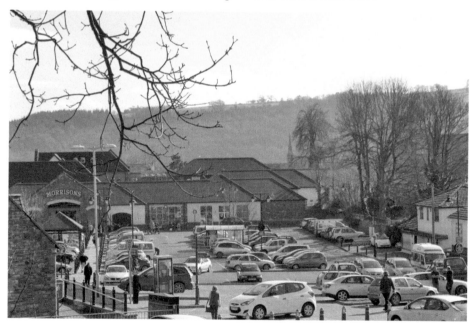

The Watton Mount *c.* 1910

Most of the buildings seen here in the early photograph remain and it continues to be one of the main arteries into the town. What, I wonder, is meant by 'the Watton'? Is it mutated Welsh, a remnant of the Norman era, or of a Saxon tongue as Watton in Norfolk is supposed to be? Like so many other Brecon street names I was unable to discover any substantial clues to its origins, but I'm sure the answer will soon follow this publication.

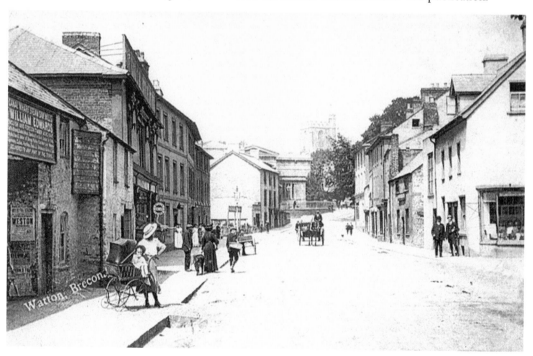

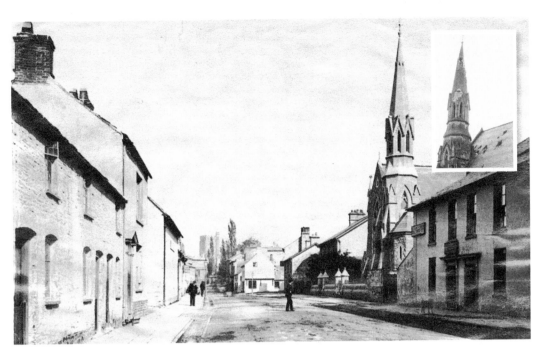

'Thunderbolt and Lightning, Very Very Frightening!'
Another view looking up the Watton towards the Bulwark. The chapel in this picture suffered a severe and unexpected freak accident in 1955, when out of the blue a thunderbolt struck the tower. It happened on a clear and sunny Saturday morning and many people witnessed the event. Surprisingly, no-one was hurt.

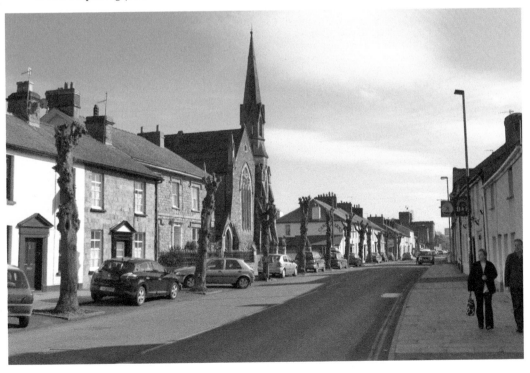

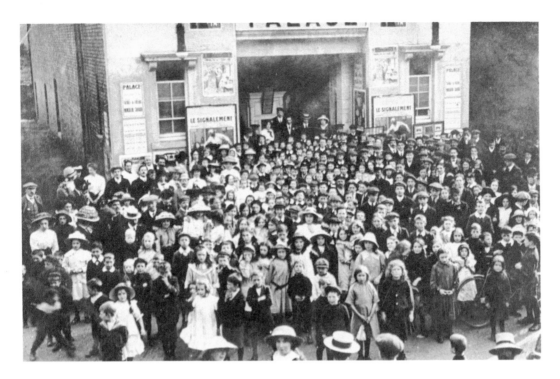

Going to the Palace

Here we see children eagerly awaiting the opening of the Palace Cinema in 1913. The film seems to have been French, but this hasn't affected the attendance, as I guess it was a silent movie. The cinema closed in the mid-1960s and has since been demolished. A modern theatre is located nearby on the canal basin and the original Palace site is now a retail area.

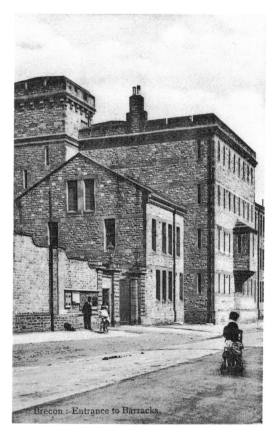

Brecon Barracks

The Barracks is undoubtedly the most significant and imposing structure in the Watton. Built as infantry and cavalry barracks in 1840, with the keep added in 1877, it is still a military base, the headquarters of 160 Brigade (HQ Wales). However, its modern role is administration and communication, rather than its former function as a recruitment and training establishment.

Brecon : Entrance to Barracks.

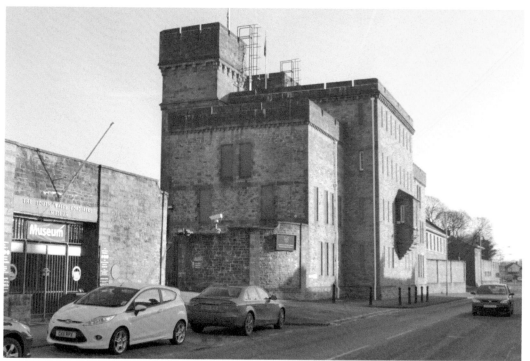

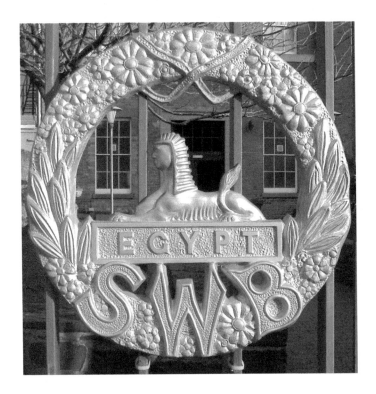

The Regimental Museum

This 'Triumphal Arch' shows the extent of the welcome for returning troops of the 23rd Regiment in October 1867, I believe, from service in Canada. It reads 'Welcome to our Gallant Countrymen the 23rd Royal Welch Fusiliers'. The 1st Battalion was at the time engaged in India in what became known as the Indian Mutiny. Soon after this the 24th Regiment made its headquarters here in Brecon and the association with this famous regiment continues to this day. Both of these celebrated regiments now form part of the Royal Welsh Regiment. The Regimental Museum holds many artefacts and items from the major campaigns of the 24th Regiment including a wonderful display of Victoria Crosses won in various conflicts, including the Defence of Rorke's Drift.

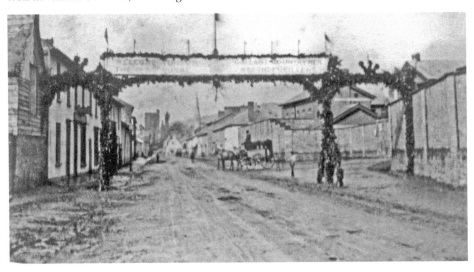

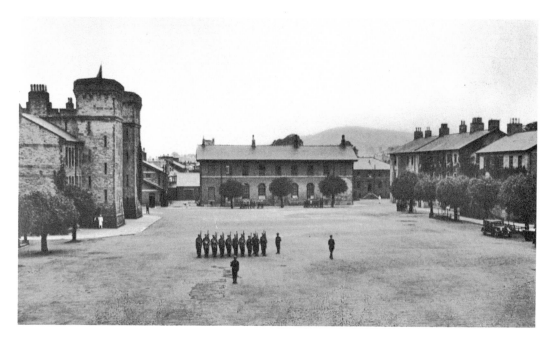

For Queen and Country

Here we see a squadron of troops drilling on the parade square of the barracks in around 1950. The buildings themselves have changed little, although much renovation was carried out during the mid-1960s, particularly to the keep. Brecon and the surrounding area remains at the heart of military training, with Dering Lines Camp on the outskirts of the town playing a prominent role in training the leaders of the British Army. In fact in the military the terms 'Basic Brecon' and 'Senior Brecon' refer to the arduous courses that have evolved here.

Taking to the Water

The Sunday School outing was once a popular event in the social calendar and often took the form of a railway journey to a seaside resort. Bethel chapel took a slightly different path in 1911 by taking to the canal. It was very well attended by children and supporters it appears! This photograph was taken at the first bridge after the canal basin, which appears to be under repair. The Brecon to Newport Canal was in direct competition with the railway companies. Once busy transporting wool and other goods through the system of locks, it now relies upon tourism for its survival.

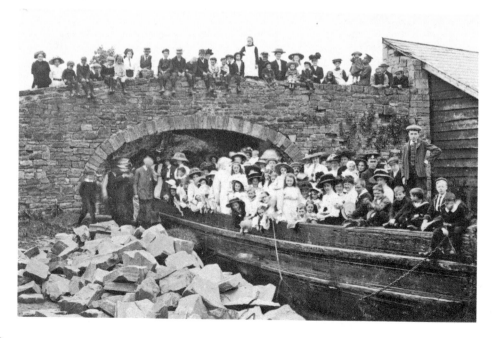

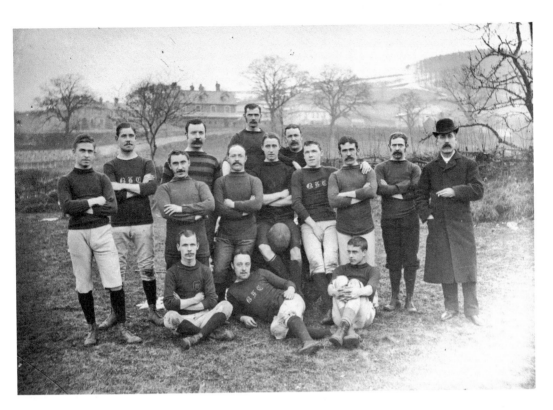

Brecon Rugby Football Club in the 1890s

This picture has been mistaken for a football picture as the logo on the shirts – BFC – has been interpreted as being Brecon Football Club. This is indeed an enigma, maybe the shirts are borrowed or even shared. Either way, the ball is definitely oval! Interestingly there only appear to be fourteen players. Brecon Rugby Club may have been outshone in recent years by its smaller neighbour Builth Wells but it is certainly making good progress, with players such as Andy Powell going on to represent Wales at the highest level.

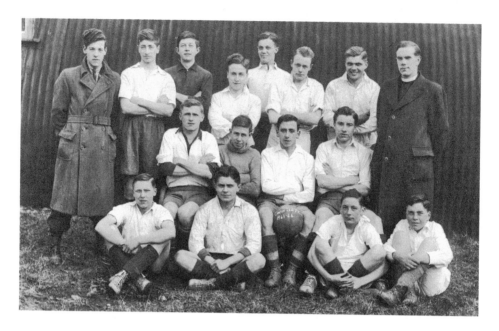

From the Rich Field

Football has always been popular in Brecon, and rivalry between local teams is evident from the banter I have come across while researching this book. Here we see the St Mary's Church Lads Brigade team from 1940. Back row: Alwyn Thorogood, John Davies, Dennis Coombe, Vernon Morgan, -?-, Steve Jenkins, ? Bowen, ? Meredith, Rev Shottelvig. Middle: Ken Smith, Trevor Cooke, -?-, John Thomas. Front: Denzil Adams, Eric Smith, Roy Perry, Billy Gallagher. Few of the early teams survive apart from Brecon Corinthians, or 'the Corries' as they are known, seen here in their red home kit at their home ground, the Rich Field. The inset shows some real life Corinthians; three generations of the same family who have captained the Corries. Arthur Bowley, (right), played his last match for his beloved Corries against Barry Town at the age of forty-seven. His son Kim (left) and his grandson Ceri also captained and played a huge part in the team's development.

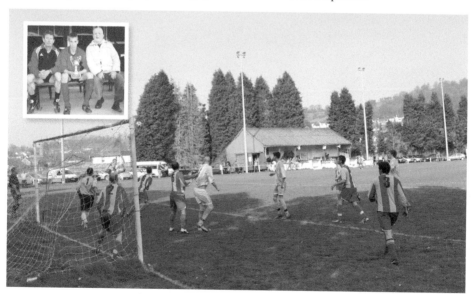

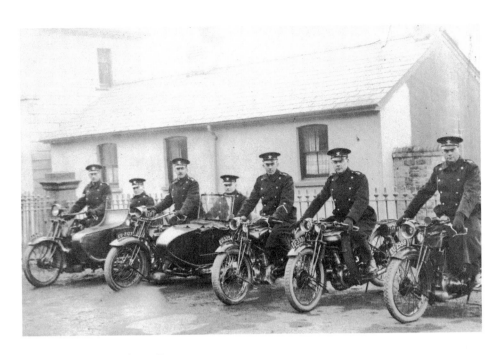

Policing the Captain's Walk

Motorcycle police before the need for motorcycle helmets apparently. EU3301 is a Norton motorcycle and the machines either side are probably the same but both have different petrol tanks. The combination EU2123 is a BSA but I was unable to identify the furthest combination. The officers are looking towards the old police station on the Captain's Walk, probably in the 1930s.

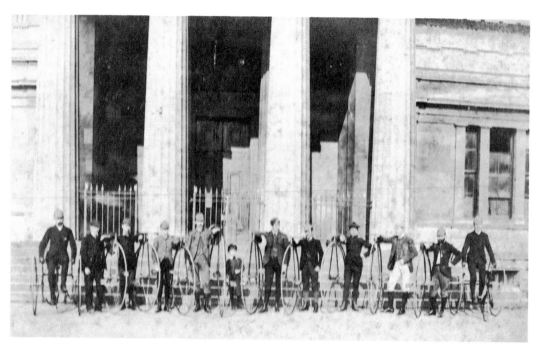

Get On Your Bike!

Cyclists with an array of penny-farthing cycles and tricycles pose outside the Crown Court building on the Watton Mount. This building, as most readers will realise, is the current home of Brecknock Museum. I guess the museum would welcome some of these cycles as exhibits nowadays.

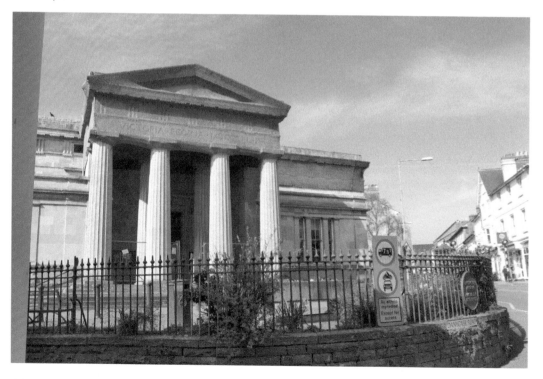

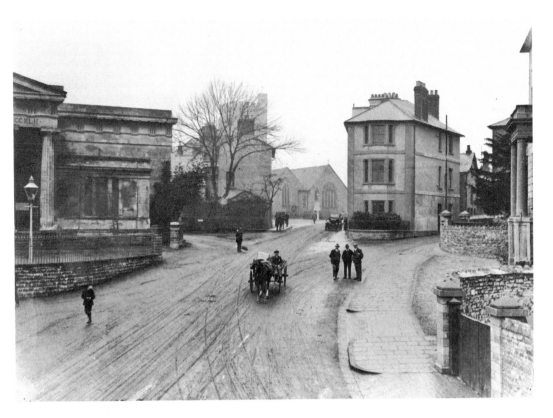

Watton Mount

A most interesting view of the Watton Mount in around 1920, with St Mary's church and the statue of the Duke of Wellington in the background. The buildings are virtually unchanged but horse-drawn transport is a rare treat in modern times.

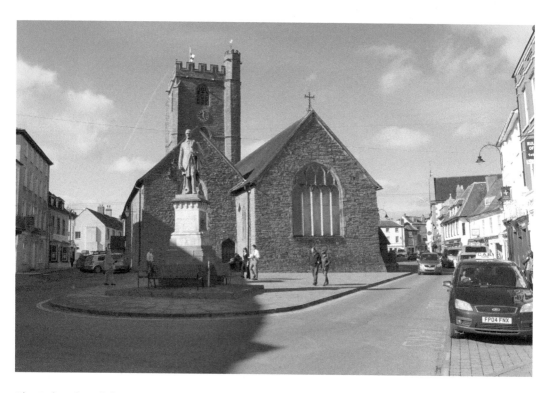

The Bulwark and the Iron Duke

A view of the Bulwark and the iconic Wellington Statue, here surrounded by iron railings. Benches have long since replaced the cage that once surrounded the Iron Duke, allowing the weary to reflect on matters of the day.

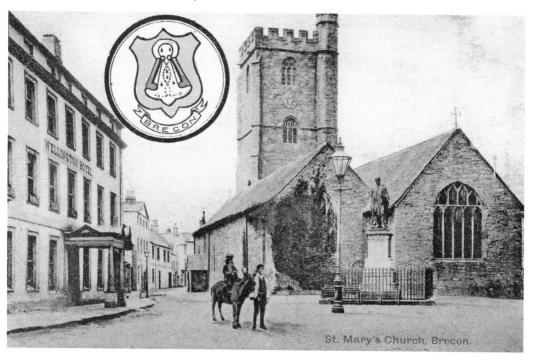

St. Mary's Church, Brecon.

Brecon's Café Royal
Many older readers will fondly remember the Café Royal that occupied all of the ground floors of these buildings. With its own bakery at the rear it produced wonderful cakes and bread to tempt the weary travellers that congregated here to travel by Western Welsh and Red and White coaches in every direction. My personal favourites were the wonderful scrumptious jam doughnuts; no-one else makes them like Café Royal bakery did!

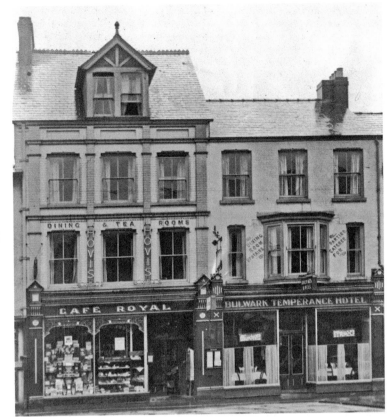

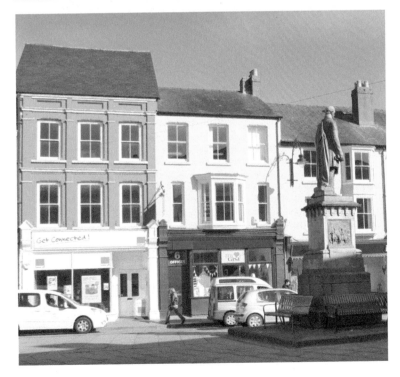

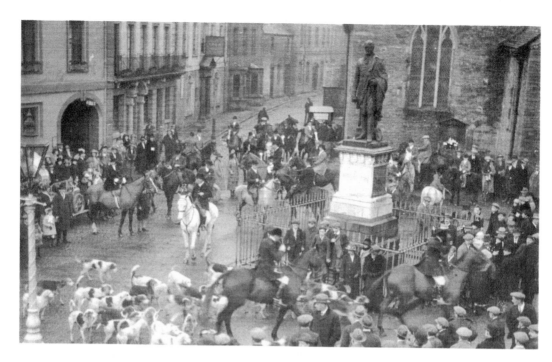

Redcoats in Brecon

The Brecon Hunt assembling in the Bulwark preparing to ride in pursuit of Brer Fox. The large sign on the building in St Mary's Street is that of the once popular YMCA (Young Men's Christian Association). Here the young men of Brecon could meet to chat and play billiards and snooker in the top-floor rooms. The modern picture shows redcoats of a different ilk: the Powys Army Cadet Force Band leads the remembrance parade through the Bulwark in 2009 – very smartly turned out too!

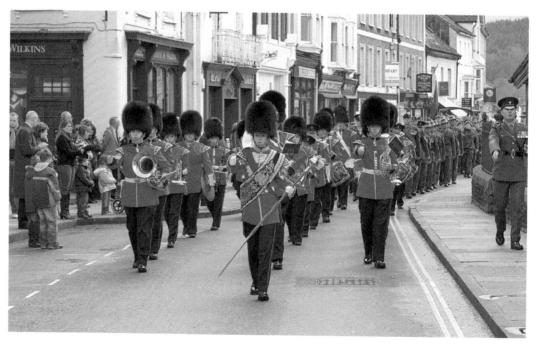

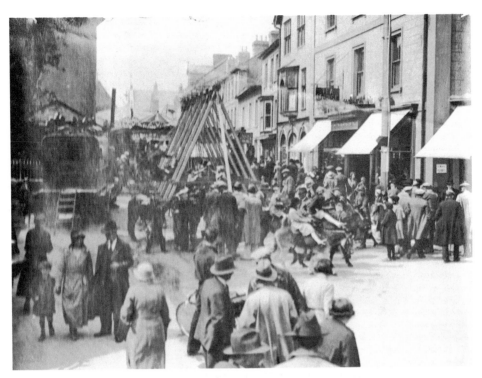

Fair Day in Brecon

This is one tradition that is still followed, as the travelling funfair occupies the town centre for two days every November and May. The rides have changed and its popularity may have waned somewhat, but although some feel it is anachronistic it continues to invoke its charter and has so far has resisted all efforts to move it from the streets. Once the fair heralded the hiring of farm servants for the season, but it is strictly recreational these days. Another attraction worth looking out for is the occasional ceremonial parades provided by visiting military units. Here we see a performance by a Ghurkha regiment in June 2009; many Nepalese soldiers and their families have settled in Brecon following postings here.

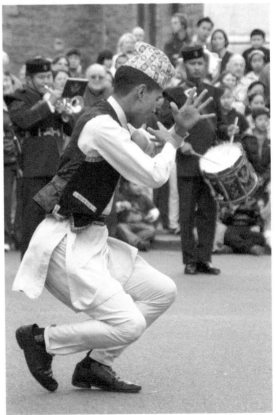

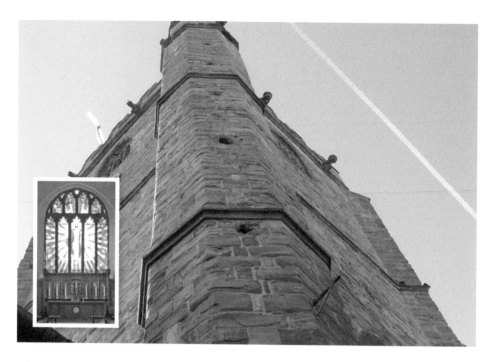

After the Fair

Brecon Fire Brigade cleaning up the Bulwark after the fair, c. 1912. The building that was to become the Café Royal is occupied by A. H. Tyler, plumber, and next door in temporary accommodation is the London and Midland Bank that has since evolved into HSBC Bank. I guess that their current premises were under construction when this was taken. It is always worth visiting the church of St Mary the Virgin in the centre of the town, but on sunny days around noon its wonderful stained glass window captures the sunlight to provide an awesome sight.

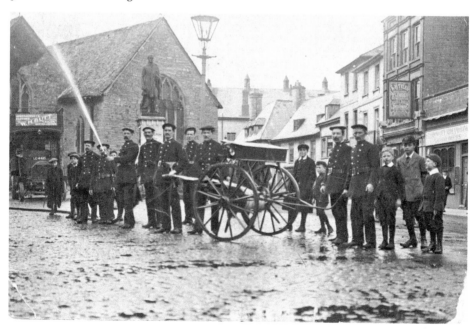

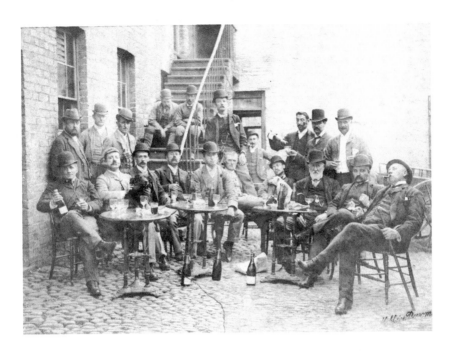

Jack the Ripper in Brecon?

A congregation of the gentlemen of Brecon enjoying a drink or two in the Wellington Hotel courtyard; the wine seems to have been flowing fairly freely. This was taken following the visit of the Duke of Clarence in September 1890, two years prior to his death. Prince Albert Victor's intellect, sexuality and sanity had been the subject of much speculation. Rumours linked him with scandals but there is no conclusive evidence verifying or disproving his sexual orientation. Some authors argue that he was the serial killer known as Jack the Ripper! The modern shot shows a gentleman taking a cigarette break on the balcony outside his workplace, smoking indoors in public areas being outlawed nowadays.

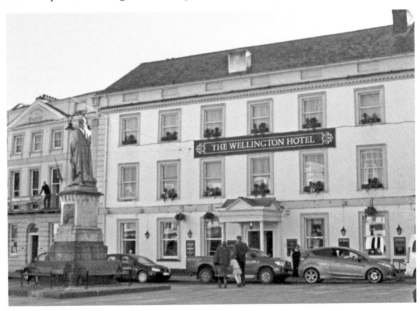

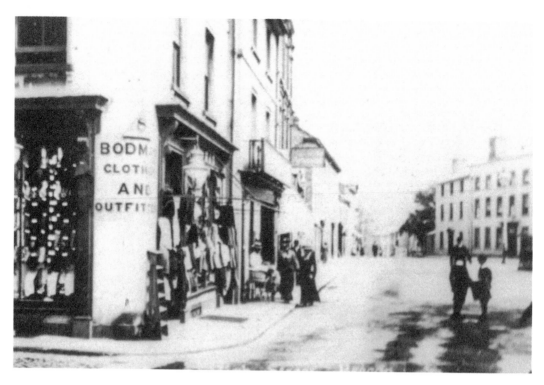

Early Shot of the Bulwark, *c.* 1900

I find this picture interesting despite its poor quality (and its being wrongly titled 'High Street'). The fashion of the day is on display in the Bodman clothing store. The spot has always been occupied by clothiers in my memory, the most famous being Watts the Clothier, which flourished right up into the 1990s. They also had shops in several other local towns.

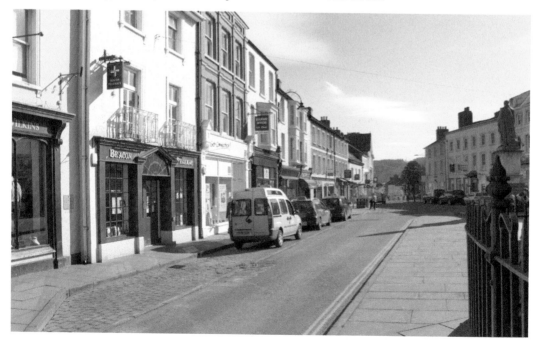

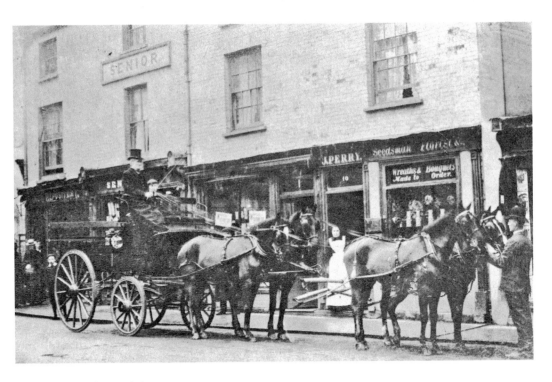

Cosmopolitan High Street

Here we see a stagecoach outside Perry's in High Street, another once famous high-street name from the past. What a magnificent sight, once an everyday occurrence in Brecon, a beautifully turned out team of four standing perfectly still as the passengers alight. The colour picture shows the very cosmopolitan ambiance that currently exists here as shoppers relax outside a local fast-food café.

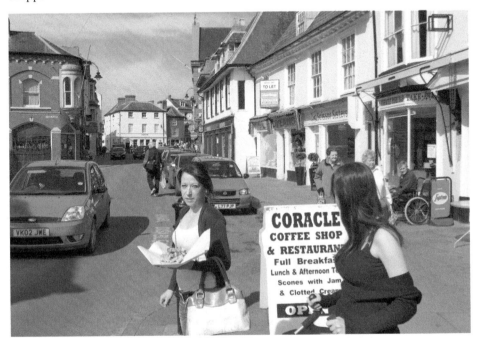

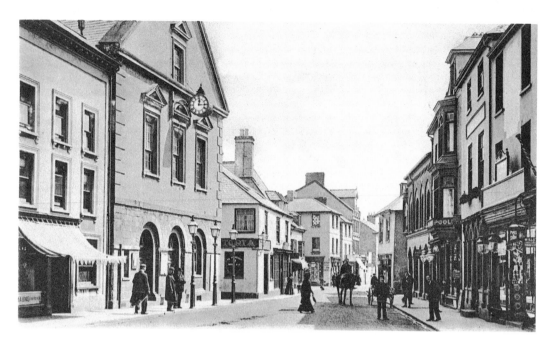

Another View of the Bulwark

Looking towards the Bulwark from High Street Superior. The Victoria alehouse has since been replaced by the bank, which readers will remember we saw in temporary premises in an earlier photograph of the Bulwark. The last building on the right of the street is gone and now forms part of St Mary's church grounds.

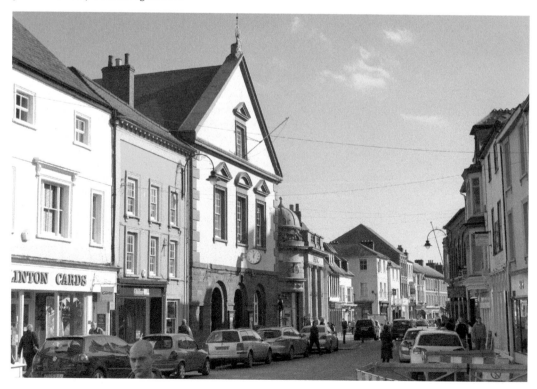

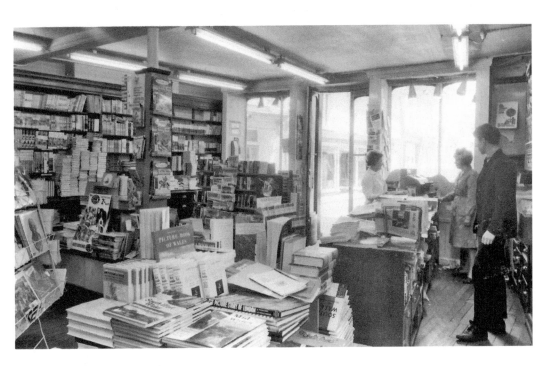

Brecon's First Pedestrian Precinct

The whole area around Bethel has been developed into a tasteful shopping mall, maintaining many of its original features. Several nationally known chain-stores have relocated here, including W. H. Smith, which moved from its original home in the wonderfully named High Street Inferior. Here we see June Vaughan serving a customer in the original High Street shop.

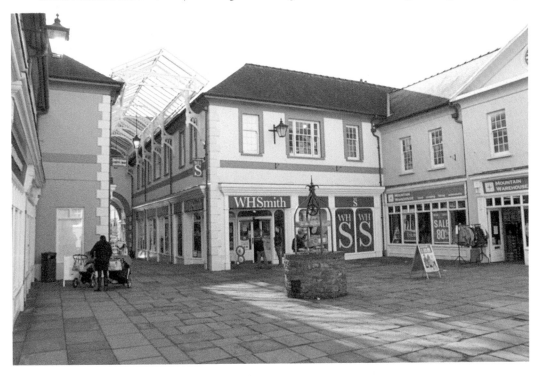

Wishing Well and Bethel Chapel

The chapel was originally entered along a short alleyway just off Lion Street, which has been adapted to develop Bethel Square. This was one of three chapels in this short and narrow street. Dr Coke's was situated near the northern end, down a short lane that now leads to the Co-op supermarket, and the Plough chapel was a little further down. The beautiful Plough chapel is the only one of these surviving as a place of worship.

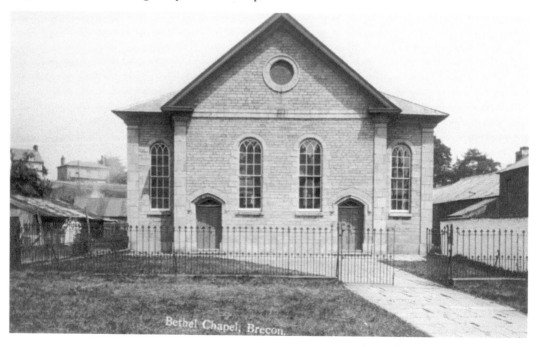

Bethel Chapel, Brecon.

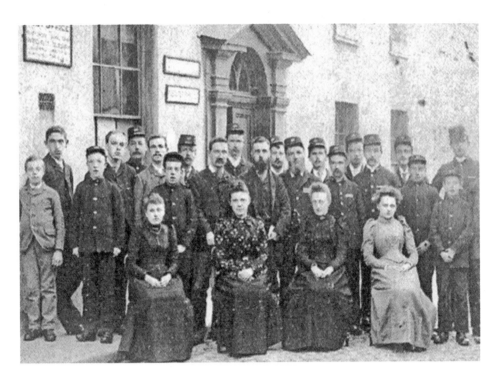

Lion Street and its Environs

The town's post office was once located in Lion Street just below the entrance to Bethel Square. The formal nature of this picture in the 1890s shows how postal workers were viewed. I presume the ladies seated are the counter staff. The postmen appear to have a hierarchy based upon how many horizontal stripes they have on their chest, and the young lads are telegram boys, delivering messages all over Brecon at high speed on their bicycles.

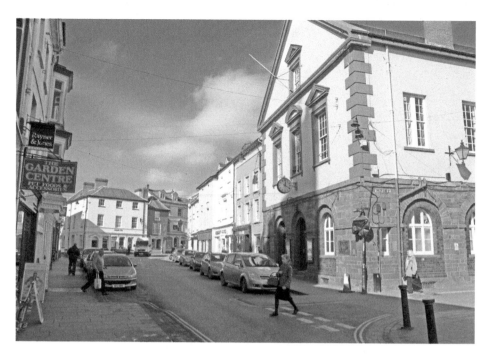

Two High Streets Are Better Than One!

High Street Superior, looking towards High Street Inferior. The shops we can see in the short and narrow High Street Inferior are a tobacconist (next to the bank) and the rest of this side of the street was occupied by W. H. Smith. The ground floor of the Guildhall was originally open plan in the form of a marketplace. It is interesting to note that the wonderfully ornate triple gas lamp and drinking fountain seen here, (the Games Fountain), was removed with great difficulty in 1934. What an awful mistake.

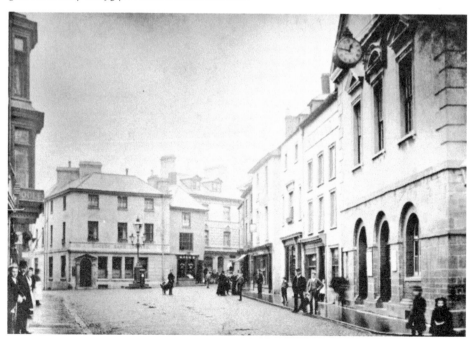

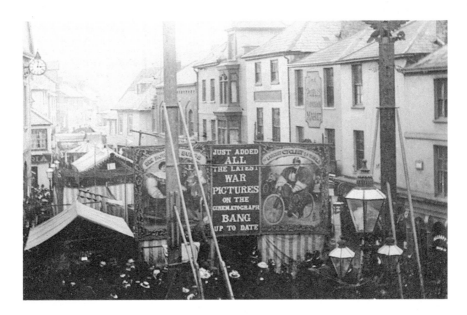

All the Fun of the Fair

A freak show in the travelling fairground offering the public the opportunity to see a grossly overweight lady burping and riding a bicycle! The Victorians had a fascination with the unusual and the grotesque. The latest war pictures on the cinematograph were from the Boer War. Cinema was very much in its infancy then and this probably caused quite a stir. I wonder just how 'bang up to date' they actually were? The fair's charter dates back to 1308. Members of the ancient Showmen's Guild often spend their entire lives with the fair, like Tracey (below centre). She has many interesting memories of Brecon Fair and the shopkeepers who she got to know very well on the fair's bi-annual visits as she grew up. Fairground people seem to look for the best in everything, and even though the weather was horrible during this visit in May 2012, Tracey and Alicia could laugh, 'At least we're on tarmac and not in a field!'

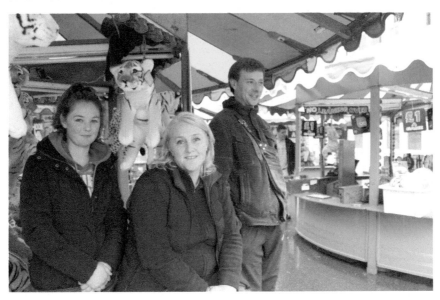

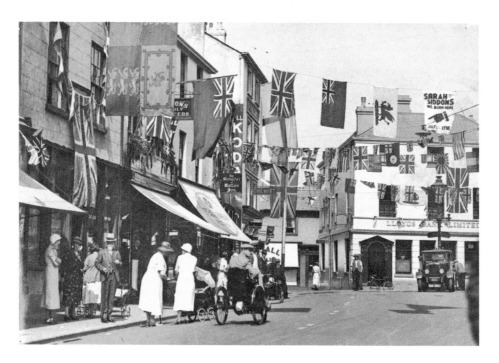

Celebration Time

In this interesting picture looking towards the Ship Street entrance to High Street Superior it is not obvious what is being celebrated; perhaps the end of the Great War or a coronation? The small motor vehicle seen here looks like the forerunner of the Sinclair Research C5, an electric vehicle invented by Sir Clive Sinclair and launched in the United Kingdom in 1985. It failed miserably!

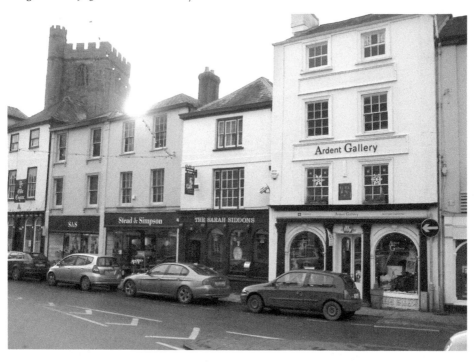

The Shoulder Of Mutton Inn

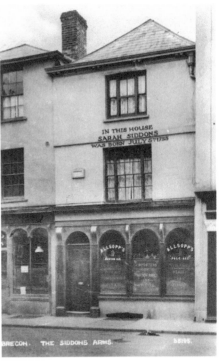

The famous actress Sarah Siddons was born on here on 5 July 1755. One of the great tragediennes of the English stage she is still widely remembered; a school is named after her and the Sarah Siddons Society in the USA awards a striking statuette replica of Sarah Siddons for an outstanding performance in a theatrical production. The original name of the inn has recently been changed in favour of the name of the actress. The modern picture shows the back street at the rear of the premises, one of the many interesting back streets of Brecon.

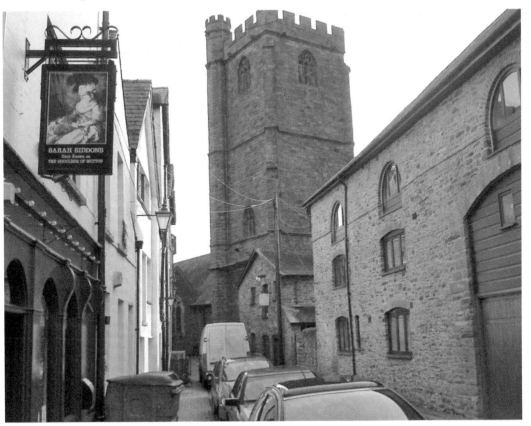

Carnival Day in Brecon

It is difficult to date this photograph accurately but we can confidently say it was around 1936. Carnival was always well supported and much time and thought went into the costumes and decoration of the floats. These 'travelling gypsies' are almost certainly ladies from the Llanfaes area. The colour photograph shows High Street Inferior.

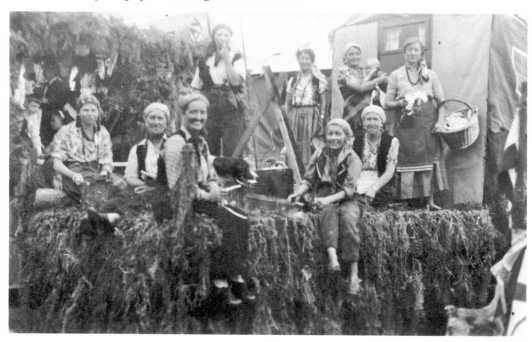

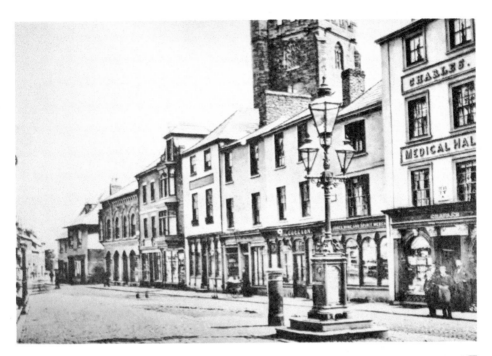

High Street Looking Towards the Bulwark

Two-way traffic wasn't a problem in the 1940s as car ownership was strictly for the better off. The working classes depended on public transport, the railways or Shanks's pony to get around, or a bicycle if one could afford it.

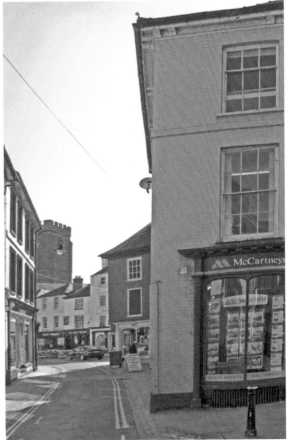

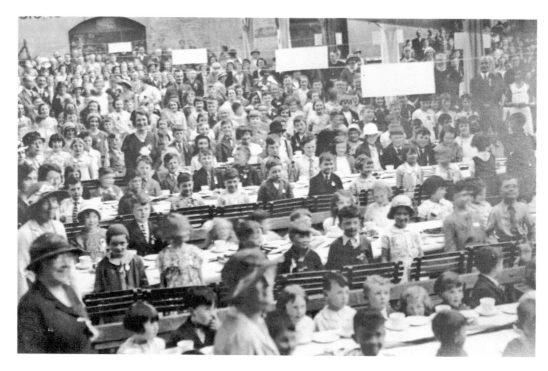

Brecon Schoolchildren Enjoying a Tea Party in the Market Hall
The occasion is believed to have been a celebration for the silver jubilee of George V in 1935. The children are wearing their silver jubilee medals. The Market Hall still thrives, with a variety of permanent businesses and weekly markets and special events in the lower market hall.

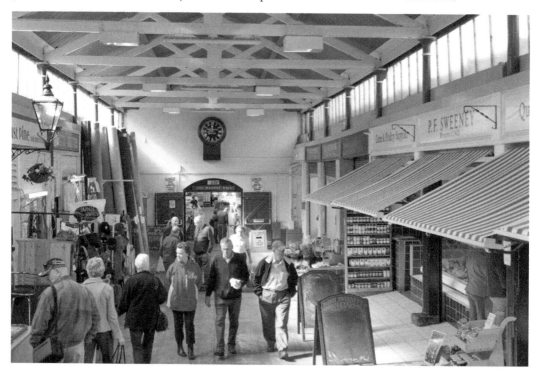

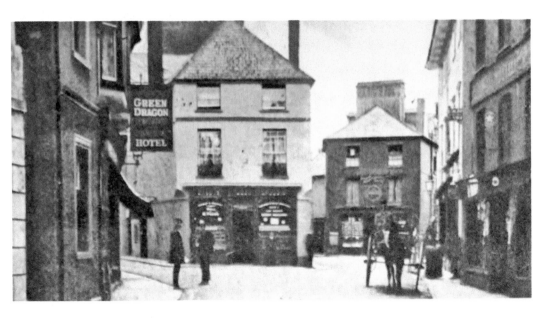

Some of Brecon's Small But Interesting Streets

The entrance to Lion Street and to the right High Street Inferior. Here also stands the town's marketplace. The market occupies the site once known as Longfellow's Garden, after a Thomas Longfellow (1727–1814), landowner and host at the Golden Lyon Inn. He was also a prominent member of the Old Cambrian Lodge of Freemasons who met at the Swan Inn in Ship Street and also kept the Bell Inn, in the lane bearing that name. All of these inns have disappeared and, with the exception of the Bell, no traces remain.

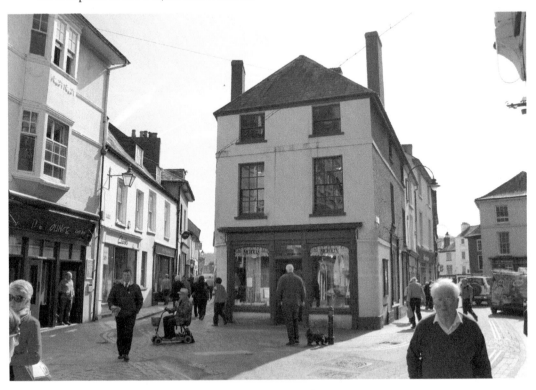

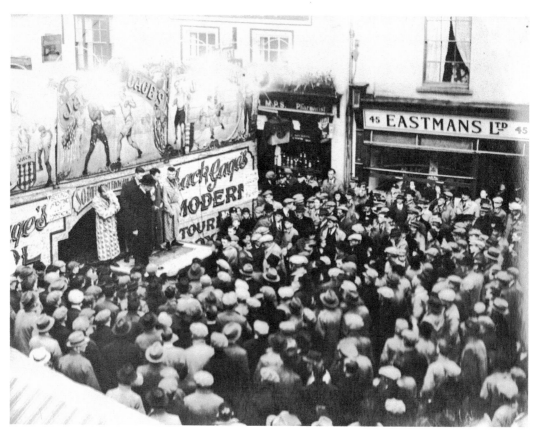

Fairground Attraction

A popular fairground attraction back in the day were the boxing booths, where all comers were invited to challenge the resident boxers. It is obvious from the crowd how popular this kind of event was in touring fairs. I wonder what became of Jack Gages and his team of boxers; did any champions emerge? Similar attractions at this time included freak shows and rather risqué dancing girls!

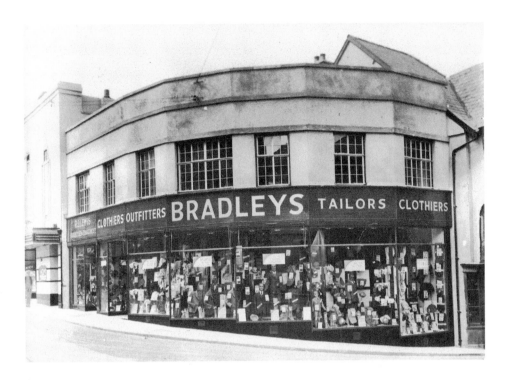

The Top of Ship Street

Many explanations for this street name have been proposed over the years, some think the name mutated from 'Sheep Street', dating from days when sheep sales were held on the streets. Another plausible explanation is that it was a mutation of 'Shipster Street', indicating the main trade that took place here. I think neither is really acceptable. In my experience, street names in Brecon and other nearby towns often take the name of a prominent inn or hotel and retain the name long after its disappearance. I believe that sometime in the distant past the Ship Inn stood somewhere along this street.

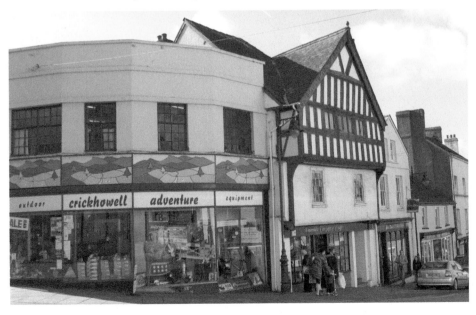

Going to the Pictures

The Electro Theatre Cinema at what is now St Michael's Hall in Wheat Street. Did this cinema eventually evolve into Brecon's only remaining cinema, The Coliseum, a few yards away on the same thoroughfare? I have tried without success to read the posters advertising the films being shown. I presume that this picture shows the opening of the cinema from the numbers present.

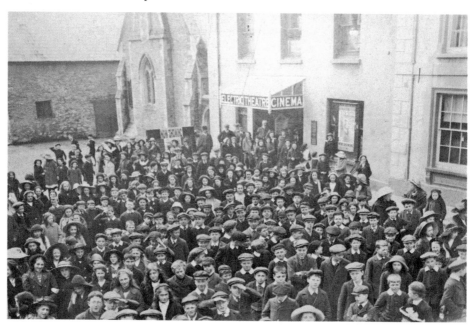

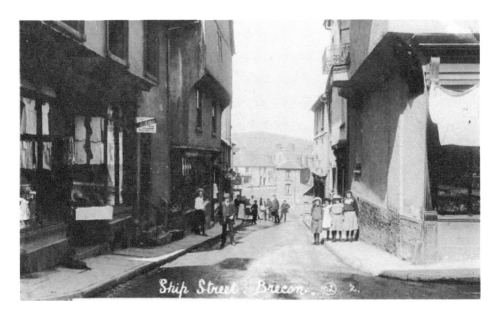

Ship Street Looking West Towards the Bridge

Gorgeous medieval buildings and interesting narrow streets – far too pretty to survive the Brecon planners? Absolutely! Almost the entire northern side was demolished and redeveloped, but at least the southern side remains. A new town library was constructed in place of the northern side. For a modern building it does have a little merit inasmuch as its walls and windows depict the pages of a book, and I suppose a town as important as Brecon deserves a decent library...

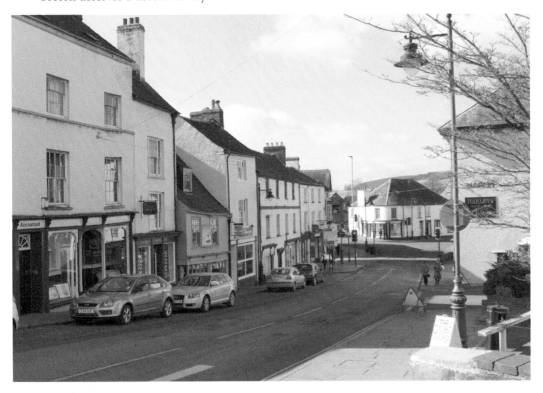

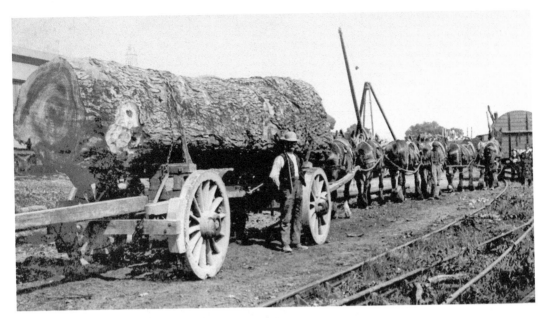

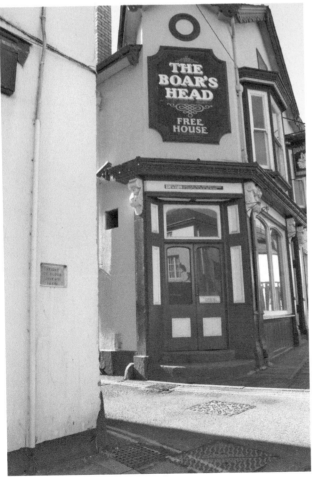

For Whom the Bell Tolls

This mighty oak was transported to the railway yard in Brecon by local company Browns of Defynnog and caused havoc when one of its wheels collapsed on the Ship Street junction, where for several days it blocked the road. It eventually continued to its destination where, it has been suggested, it suspends the great bell Big Ben in the Palace of Westminster. This picture dates from around 1895 so this is most unlikely to be true as the bell was hung many years earlier. A small plaque on the wall of the building at the junction of St Michael Street marks the height of the water during a great flood of July 1853. One can only speculate at the relative disaster that must have befallen Llanfaes as the town side of the bridge usually escaped the floods that Llanfaes suffered. This building once housed Brecon's Co-operative Store or the 'Kwarp', as many local ladies referred to it!

All For a Day's Work

This old picture carries a reminder of times we don't really wish to return to. Out-of-work men once congregated outside this building at the top of Ship Street hoping to be selected for a day's work. The damage to the building is reputed to have been caused by tanks returning from the war being transported through Brecon in the 1950s. This small street marks the beginning of High Street Superior, making a sharp turn into the town centre at the top of Ship Street. Its sister street, High Street Inferior, begins at the grey building seen at the streets' confluence.

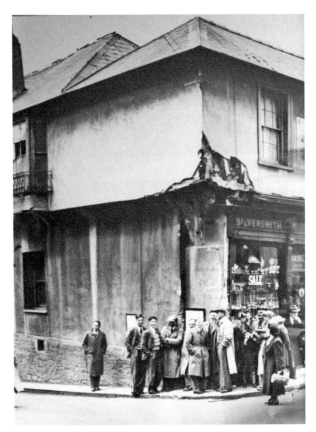

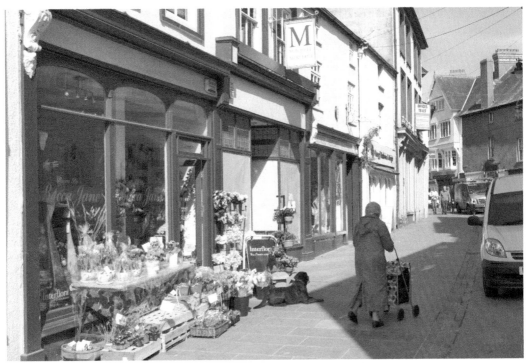

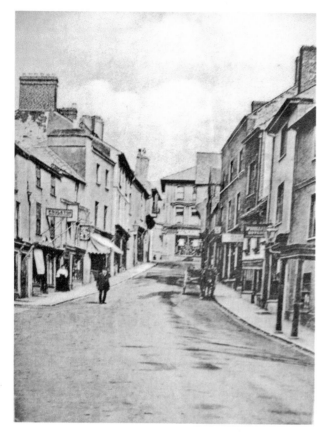

Ship Street From the Bridge

The modern picture looking up Ship Street shows the entrance to St Michael Street near the bridge and the popular Boar's Head Inn. To the left a new traffic relief road begins, taking traffic along Market Street and away from the town centre. It is not popular with local people in general.

The older shot shows the entire row that was demolished in an earlier attempt to manage traffic. The planners are threatening to redevelop the entire area on the left of this picture up to and including Bell Lane and the town's library, which replaced all of the buildings seen here!

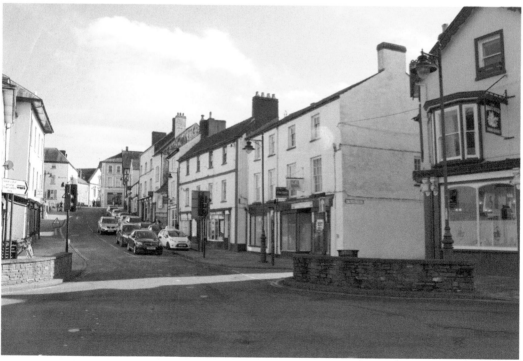

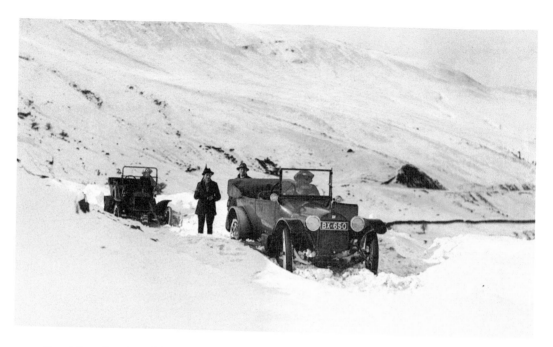

Great Penyfan, Watching Over the Town!

The Beacons may be friend or enemy depending upon the season, or sometimes just the time of day. Maybe becoming stuck in snowdrifts was a novel occurrence in 1910 when driving was something of a novelty, as the participants seem to be enjoying the experience.

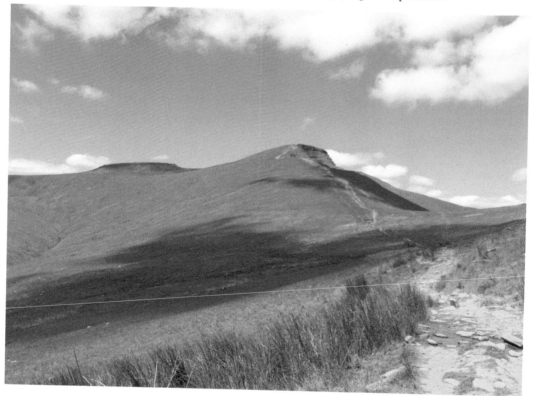

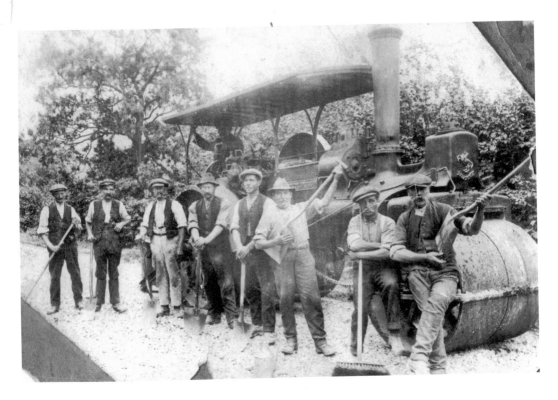

Roadmen Near Brecon, *c.* 1930

Thanks

So many people have helped in the production of this book that is difficult to know where to begin and I feel sure that I will accidentally miss someone who has made an important contribution. My apologies if I have.

Thanks to my wife, Sue Morrison, for her help and support, and special thanks to Felicity Gill for her valuable help reading, correcting and giving advice throughout. To Catherine Richards and her staff at the Powys County Archives, Llandrindod Wells; to the Curator and staff at Brecknock Museum; to the Clark family of Brecon for allowing me access to their vast collection; to David Meacham of Pickledegg Design and Photography; to Rhion Johnston, Felicity Kilpatrick and Sarah Williams of Christ College; and to Mrs Ishbel Jenkins, Kim Bowley, and David and Mandy Williams of Old Castle Farm Guest House for the use of many of their photographs; also to Celia Green of the Museums of the Royal Regiment of Wales (24th/41st), and to Amberley Publishing for making this book happen.

While reasonable efforts have been made to secure permissions to reproduce photographs and to ensure the accuracy of statements made, for any error or omission I can only offer my sincere apologies. My own (opinionated) anecdotal comments are intended to add colour and humour and are usually more subjective than objective. Hopefully they will not offend!

Mal Morrison, 2012